IMAGES OF AMERICA

EAST BOSTON

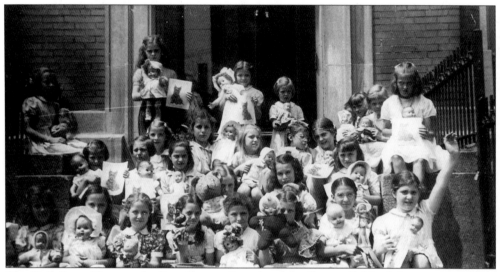

The Doll Story Hour at the East Boston Branch of the Boston Public Library on Meridien Street was a popular and well-attended afternoon event in the 1940s. (Courtesy of the East Boston Branch, Boston Public Library, hereinafter referred to as the BPL)

IMAGES OF AMERICA

EAST BOSTON

ANTHONY MITCHELL SAMMARCO

ARCADIA

First printed in 1997
Reissued in 2004

Published by Arcadia Publishing,
and imprint of Tempus Publishing, Inc.
Charleston SC, Chicago, Portsmouth NH, San Francisco

Printed in Great Britain

Library of Congress Catalog Card Number: 2003110946

For all general information contact Arcadia Publishing at:
Telephone 843-853-2070
Fax 843-853-0044
E-mail sales@arcadiapublishing.com
For customer service and orders:
Toll-Free 1-888-313-2665

Visit us on the internet at http://www.arcadiapublishing.com

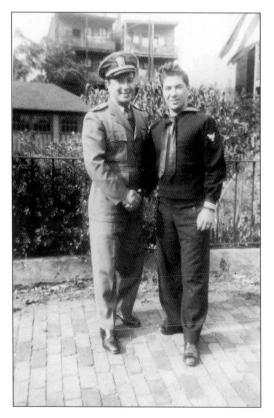

Standing on Frankfort Street on a leave
during World War II are brothers
Alexander Struzziero (a senior grade
lieutenant on a landing ship) and Anthony
Struzziero (a second class pharmacists'
mate). (Courtesy of Kenneth Turino)

Contents

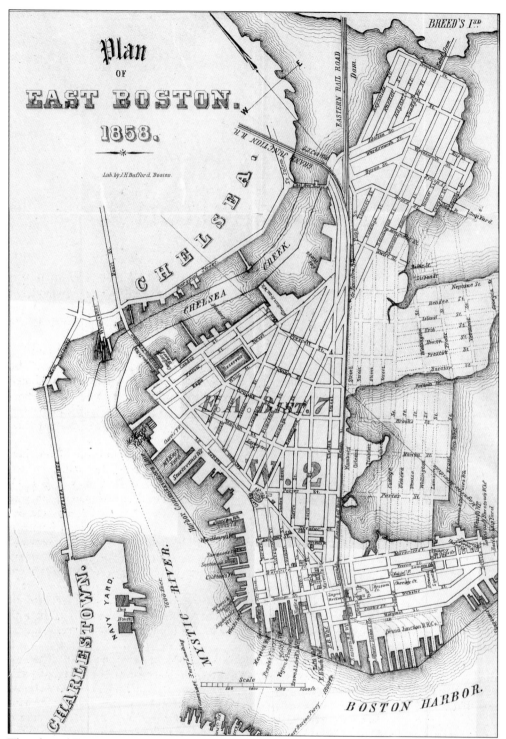

The plan of East Boston in 1858 was drawn by J.F. Bufford, a Boston lithographer. The streets had only been partially laid out in the two decades since 1833, when the East Boston Company began the development of the island. (Courtesy of the BPL)

6

Introduction

East Boston is more than just the location of the Logan International Airport, it is a neighborhood that was "layd to Boston" in 1636, making it one of the oldest neighborhoods of the city. Once comprised of five separate islands (Noddle, Hog, Governor's, Bird, and Apple Islands), the area supplied firewood and open land for grazing cattle throughout the seventeenth and eighteenth centuries.

Originally known as Noddle's Island for William Noddle, "an honest man" who was made a freeman in 1631, it is Samuel Maverick who is considered the first resident of East Boston. The son of Reverend John Maverick of Dorchester, Samuel Maverick was granted "five hundred acres for the pasturing of his cattle," and he dispensed great hospitality from his island home. During the American Revolution, the Battle of Chelsea Creek, the first naval battle of the war, took place between the British and the colonists. However, it was not until 1833 that any great changes were to take place on the island.

William Hyslop Sumner had inherited a third of Noddle's Island through his mother, Elizabeth Hyslop Sumner. His relatives, David Hyslop and David Stoddard, were induced to sell their interest in the island to Sumner and he incorporated the East Boston Company in 1833. The "company's shares were quickly taken, and lands were reclaimed, streets mapped out, and building sites set off and sold." Maverick and Central Squares were laid out as parks and the Maverick House was built near the ferry landing. To encourage new residents to build homes in East Boston, two ferries, the *Maverick* and the *East Boston*, began transporting passengers and freight in 1835, connecting Boston and the new neighborhood. In 1836 the Eastern Railroad Company was established, and its terminus was built near Maverick Square. An even more momentous event occurred in 1839, when the Cunard Line established its United States port in East Boston. From here its ships sailed for Liverpool, England. Throughout the nineteenth century, passengers sailing abroad would often stay at the Maverick House prior to sailing with the Cunard and train lines and enjoy the fine cuisine and accommodations offered in East Boston.

The development of East Boston was to consist of 633 acres of upland and marsh. The East Boston Company began the massive project by filling in marshland and continuing the development of the three wards: Jeffries Point, named in honor of Dr. John Jeffries, whose house was "like a bird's nest" on the southern slope of Webster Street; Eagle Hill, named after bird streets such as Falcon, West and East Eagle, and Condor Streets, also the site of streets named after various poets (including Coleridge, Horace, and Wordsworth) and prominent towns of the American Revolution (such as Princeton, Bennington, Lexington, Saratoga, Eutaw, Monmouth, and Trenton Streets); and Orient Heights, the last area to be developed, named in recognition of the China Trade with the Orient during the nineteenth century that brought

such prosperity to Boston.

East Boston's population had grown tremendously by the time of the Civil War, and numerous manufacturing concerns eventually located along the ample waterfront. With a population of 16,000 in 1860, East Boston "contained 1,879 dwellings, eleven churches, ten schoolhouses, twenty-four manufactories and mills, seventy-six warehouses and stores, one hundred and nine mechanics' shops, several hotels, five fire-engine houses, twelve counting rooms and seventy-seven stables." The population included Irish, Canadian, Russian, Polish, and Italian immigrants. East Boston was a multi-cultural neighborhood of people who came from all walks of life, much like today. With the building of the underwater tunnel between Boston and Maverick Square at the turn of the century, the streetcars that connected all parts of the island could now reach downtown Boston in seven minutes.

Today, East Boston is a thriving nexus of cultures, with new immigrants from South America and the Far East adding their cultures to those that came to East Boston during the last century and a half. The neighborhood can lay claim to two "firsts" in history: the first branch library in this country and the first chartered yacht club in New England (Jeffries Point Yacht Club, 1879). The grid plan of streets laid out by the East Boston Company are lined with well-kept and architecturally significant houses, many with superb views of Boston Harbor and the surrounding towns. East Boston is more than just the site of an international airport, it is a neighborhood of people who live in a historically rich area and who share in a strong tradition of justifiable pride in their community.

One
Early East Boston

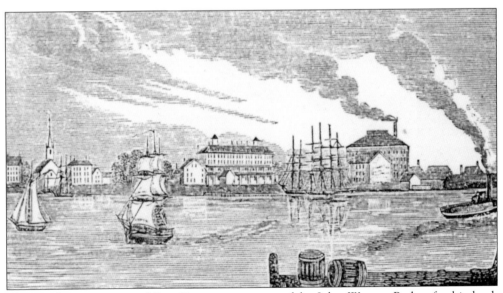

This southwestern view of East Boston was engraved by John Warner Barber for his book *Historical Collections of Massachusetts* in 1839. In the center can be seen the Maverick House, a hotel noted for its "fish dinners and other jollifications," named in honor of Samuel Maverick.

Henry Howell Williams (1736–1802) and his son Thomas leased Noddle's Island from the Bell family from 1764 to 1830. During the Revolution, the island was occupied by the British, who carried off Williams' stock and burned his home. After the British evacuated Boston in 1776, he received as recompense from General Washington the building used as barracks at Cambridge, which was floated by barge to the island.

The first residence built in East Boston after 1833 was that of Guy Haynes, Esq. Located in Jeffries Point (Ward 1) at the corner of Webster and Cottage Streets, it was a commodious wood-framed house that became the prototype for houses built during the first decade.

William Hyslop Sumner, the son of Governor Increase Sumner, founded the East Boston Company on March 25, 1833. A land developer who laid out Sumner Hill in Jamaica Plain, William Sumner laid out a grid plan of streets on the former Noddle's Island and named the development East Boston.

EAST BOSTON COMPANY. No.

BE IT KNOWN, That Proprietor

of Shares in the Capital Stock of the EAST BOSTON COMPANY, subject to all assessments thereon, and to the provisions of the Charter and the By-Laws of the Corporation, the same being transferable by an assignment thereof on the books of said Corporation or by a conveyance in writing recorded on said books — and no transfer will be complete until made or recorded in the books of the Corporation, and this certificate surrendered, when a new certificate or certificates will be issued.

Dated at Boston, this day of

Seal of the }
Company, } A. D. one thousand eight hundred and

PRESIDENT.

TREASURER.

The East Boston Company issued 5,280 shares of common stock, which were purchased by forty shareholders. The investment was used to develop the island as not only a residential district but to attract commercial development along the waterfront. The first directors were William H. Sumner, Stephen White, F.J. Oliver, Samuel Lewis, Daniel Brodhead, Amos Binney, and Gardner Greenleaf.

MAVERICK HOUSE,

EAST BOSTON, U. S. AMERICA.

NEAR THE LANDING OF THE BRITISH STEAM SHIPS. AND THE DEPOT OF THE EASTERN RAIL ROAD.

At this Hotel Ladies & Gentlemen will find every desirable arrangement provided for their comfort and every effort made to render the "Maverick House" in all respects worthy their patronage R. E. MESSINGER.

N. B. Table d'Hôte at ½ past 2. Breakfasts, Dinners &c in the Coffee Room at all hours

Collation given by the BOSTON INDEPENDENT CADETS, to the SALEM CADETS, June 17th, 1843.

BILL OF FARE.

ROAST.

Chickens.	Ducks.
Geese.	Pigeons.
Beef.	

BOILED.

Turkey and Oyster Sauce.
Tongue.
Fowl.
Salt-petred Beef.

ENTREES.

Beef a la Mode.
Lobster Sallad.
Chicken do.
Oyster Patties.
Fried Potatoes.
Calfs foot Jelly.
Puddings, Pies, Tarts and Blanc Mange.

DESSERT.

Almonds.	Pine Apples.
Oranges.	Prunes.
Raisins.	Ice Creams.

WINES.

Hock, Vintage 1834.
Sherry, do. 1830.

The Bill of Fare for a collation given by the Boston Independent Cadets to the Salem Cadets on June 17, 1843, at the Maverick House was not only copious, but varied in the entrees, desserts, and wines. (Courtesy of Stephen D. Paine)

12

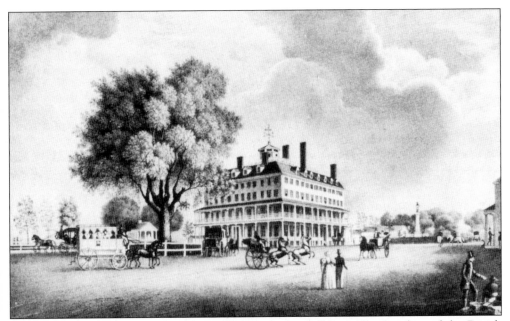

The Maverick House was a popular hotel that was located "near the Landing of the British Steam Ships, and the Depot of the Eastern Railroad." Built in 1835 in Maverick Square, it had a superb view of Boston Harbor and attracted visitors to East Boston who often sat under the willow tree on the left and discussed "land speculation or politics, as the occasion dictated."

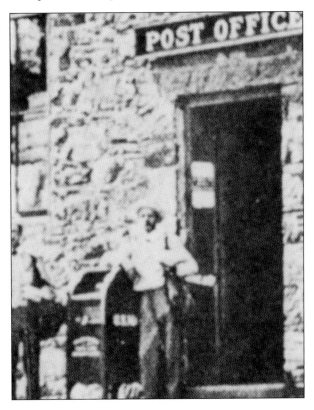

Two postmen with mailbags stand on either side of a mailbox outside the East Boston Post Office in the late nineteenth century. (Courtesy of the East Boston Savings Bank)

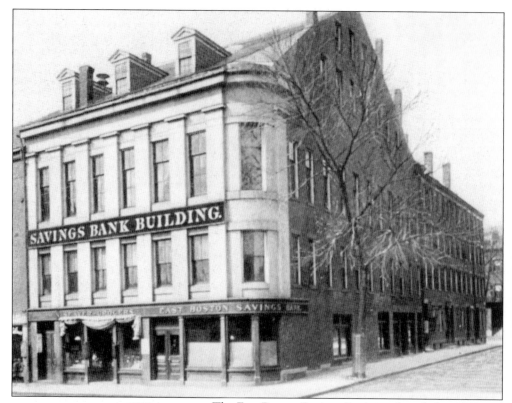

The East Boston Savings Bank was founded in 1848 and was located in this granite-faced building at 16 Maverick Square on the corner of Henry Street. (Courtesy of the East Boston Savings Bank)

James Cunningham was the first president of the East Boston Savings Bank, serving from 1848 to 1851. (Courtesy of the East Boston Savings Bank)

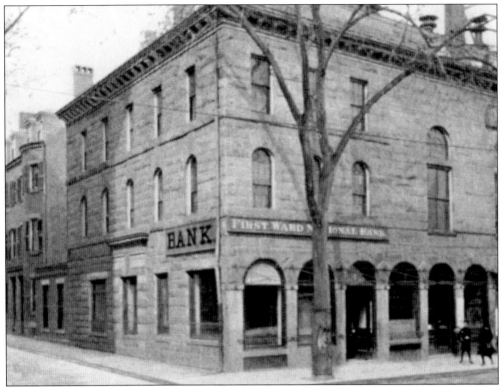

The First Ward National Bank was founded in 1873 and was located in the Winthrop Block at the corner of Maverick Square and Winthrop Street. The rough hewn granite wall of the first floor still survives.

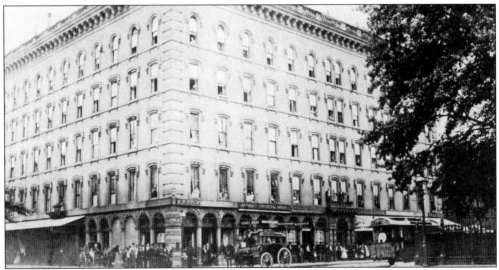

The third structure of the Maverick House was an impressive Italianate brownstone-and-brick hotel, five stories high, that became a popular place for Europe-bound travelers to spend the night prior to sailing. Designed by William Washington and known as the Sturtevant House, in honor of its owner Noah Sturtevant, it faced Maverick Square between Henry and Winthrop Streets. (Courtesy of the BPL)

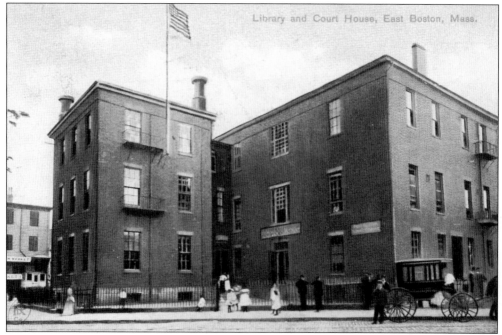

The East Boston High School, the library, and the court house were on Paris Street in the late nineteenth century. The first branch library in the United States was opened in East Boston in 1870.

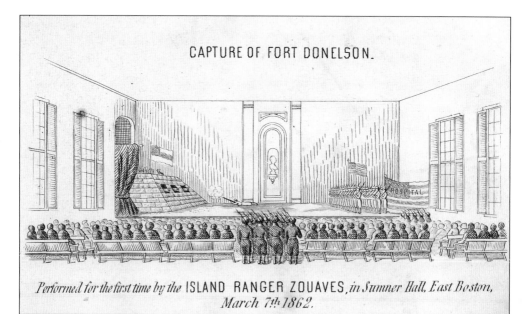

CAPTURE OF FORT DONELSON.

Performed for the first time by the ISLAND RANGER ZOUAVES, *in Sumner Hall, East Boston,*
March 7th 1862.

On March 7, 1862, a reenactment of the capture of Fort Donelson was performed in Sumner Hall at Maverick Square by the Island Ranger Zouaves, a cadet group from East Boston.

The Honorable Benjamin Pond was the first Standing Justice of the Municipal Court of the East Boston District, serving from 1874 to 1886. (Courtesy of the BPL)

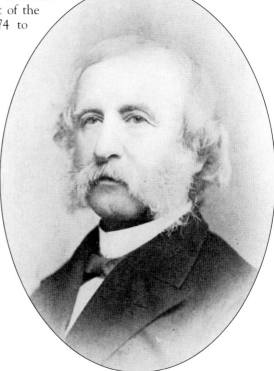

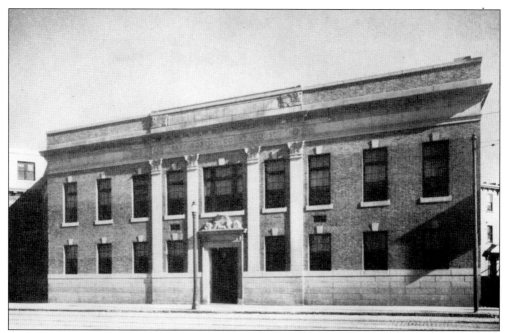

The present East Boston District Court was designed by the architectural firm of Mc Laughlin & Burr and dedicated on June 30, 1931. (Courtesy of the BPL)

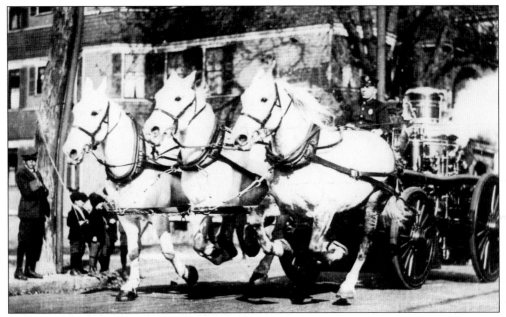

A horse-drawn chemical engine of the Boston Fire Department races down Bennington Street at the turn of the century. By 1860, the following engines were kept in East Boston: the Maverick, Sumner Street, the Dunbar, Central Square, the Webster, Chelsea Street, Washington Hook and Ladder, Paris Street, and the Deluge Hose, Paris Street.

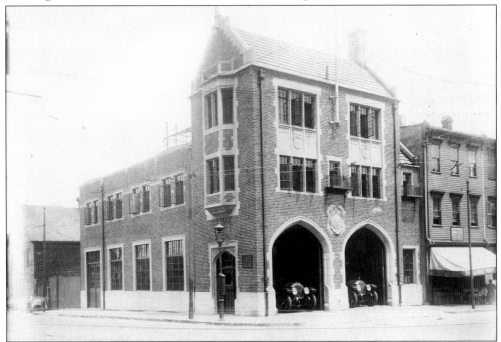

Engine 40 of the Boston Fire Department was built at the corner of Sumner and Orleans Streets. Fire engines are parked in readiness just inside the doors of the brick-and-limestone Gothic firehouse. (Courtesy of the Society for the Preservation of New England Antiquities, hereinafter referred to as SPNEA)

Henry Bozyol Hill was the president of Hill & Wright, later known as the New England Steam Cooperage Company. He also served as a member of the House of Representatives and the state senate from East Boston.

John J. Douglass was a member of the House of Representatives at the turn of the century. A native of East Boston, he was not only an attorney but a noted journalist.

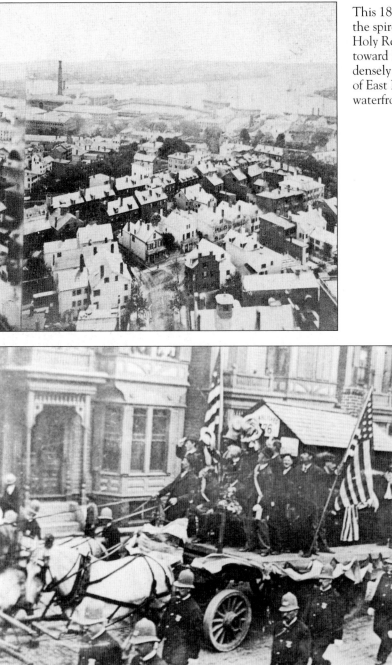

This 1880s view from the spire of the Most Holy Redeemer Church toward Boston shows a densely built up section of East Boston and its waterfront.

The Little Red School House was a float in a parade celebrating Independence Day in 1895. Proceeding along Meridien Street, the parade participants were later to be involved in an anti-Catholic riot, despite the large number of policemen walking alongside the float. (Courtesy of the BPL)

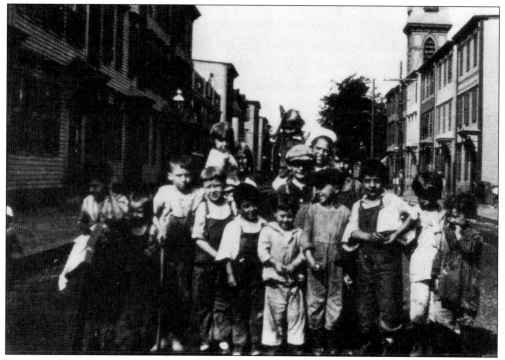

A group of boys pose in the middle of Brooks Street in the 1940s. On the right can be seen the spire of the Sacred Heart Church. (Courtesy of the BPL)

A Sunday Afternoon Leaders' meeting was held at the Marginal Street Center in 1949. (Courtesy of the East Boston Savings Bank)

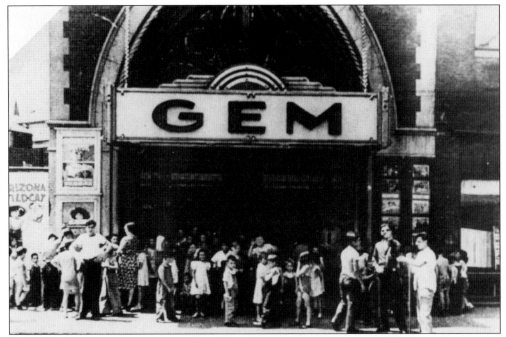

The Gem was a popular movie house on Meridien Street between Maverick and Central Squares. A group of children wait to enter the theatre for the Saturday afternoon matinee. (Courtesy of the East Boston Savings Bank)

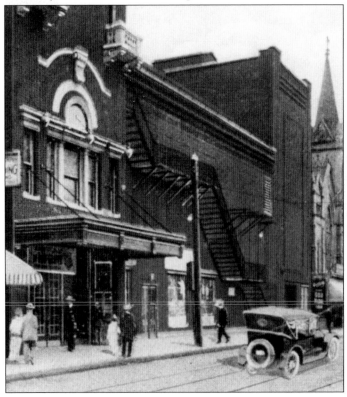

The Central Square Theatre was one of four theatres in East Boston; the other three were the Seville, the Gem, and the Orient Palace. The theatres usually offered two movies with a premium of a piece of dinnerware for 35¢ on Monday and Tuesday evenings. (Courtesy of the East Boston Savings Bank)

Two
Maverick Square and Jefferies Point

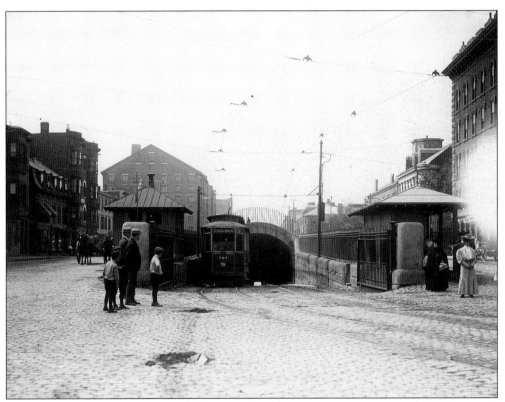

A streetcar bound for Chelsea emerges from the tunnel at Maverick Square about 1908. Streetcars could travel from East Boston to downtown Boston in seven minutes via the first underwater tunnel in the country. On the right can be seen a corner of the Maverick House. (Courtesy of SPNEA)

The underground tunnel, which took from 1900 to 1904 to complete, emerged just east of Sumner Street. The cupola of Lyceum Hall and the East Boston Savings Bank are visible to the left of the Maverick House.

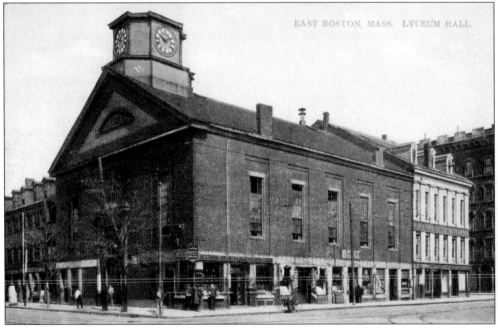

Lyceum Hall was built at the corner of Maverick Square and Sumner Street. Erudite and popular lectures were offered in Sumner Hall for the public's benefit in the nineteenth century. To the right can be seen the East Boston Savings Bank.

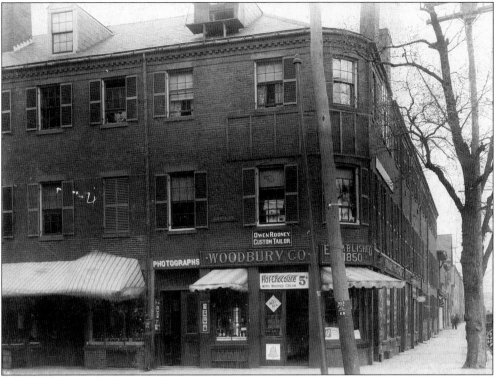

Woodbury & Company was founded in 1850 and was located at the corner of Sumner and Lewis Streets. (Courtesy of SPNEA)

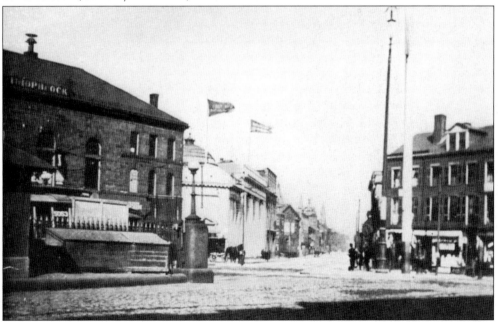

Looking north from Maverick Square, the Winthrop Bank in the Winthrop Block is on the left, followed by the Enterprise Co-Operative Bank and the Columbia Trust Company. Meridian Street leads north to Central Square and continues to the Chelsea Bridge.

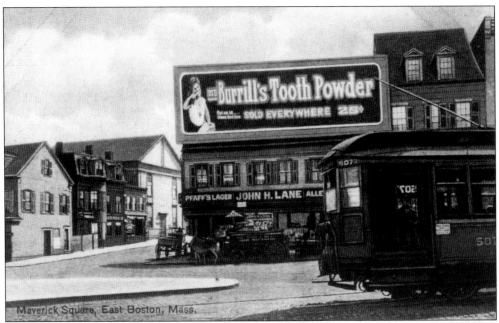

John H. Lane had his ale and lager store at the corner of Maverick Square and Gove Street. A large sign for Burrill's Tooth Powder, a forerunner to toothpaste, surmounted the roof at the turn of the century.

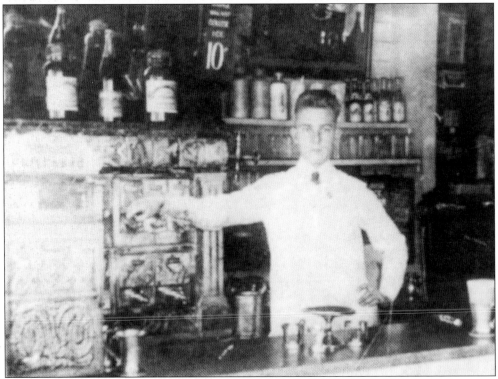

A "soda jerk" poses at the counter of Packard's Drug Store in Maverick Square in 1923. (Courtesy of the East Boston Savings Bank)

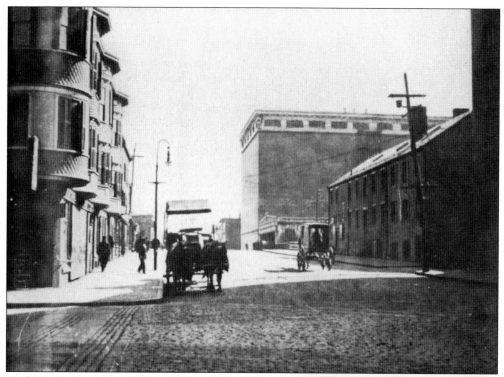

Looking southeast from Maverick Square, Sumner Street had three deckers above the stores on the left and a large warehouse on the right.

Gilda Pisapia and Joseph Sammarco pose for a photograph on their engagement day on Chelsea Street. Leaning on the porch railing are Luigi Pisapia (left) and Ray Pisapia. (Courtesy of the Sammarco Family)

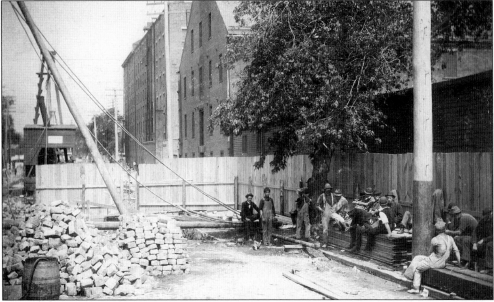

Workmen take a break on Lewis Street as they dig the underwater tunnel in the summer of 1900 that would connect East Boston to downtown Boston. (Courtesy of SPNEA)

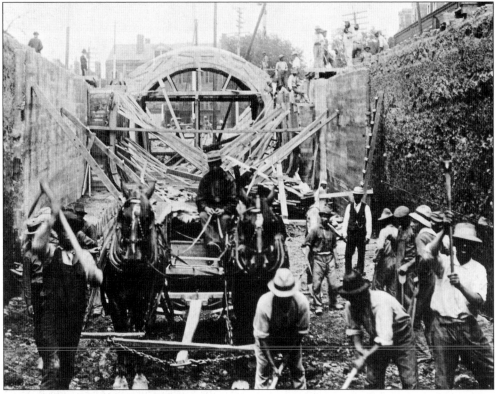

With picks and shovels these workmen prepare the tunnel in Maverick Square in the summer of 1900. A team of horses dredge the rough base surface as the wood-framed supports are erected for the roof of the tunnel. (Courtesy of SPNEA)

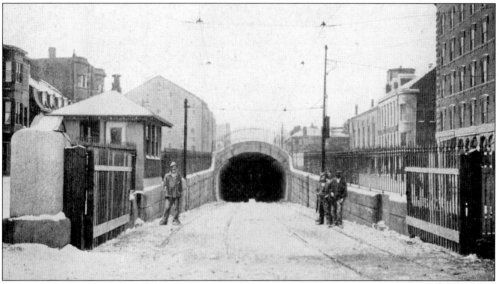

Men stand on either side of the entrance to the East Boston Tunnel in 1905. A marvel for its day, it reduced the time of the East Boston to Court Street Station route to seven minutes.

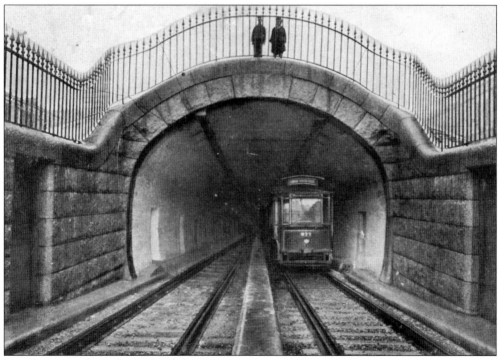

Two boys stand on the arch of the East Boston tunnel as a streetcar emerges at Maverick Square.

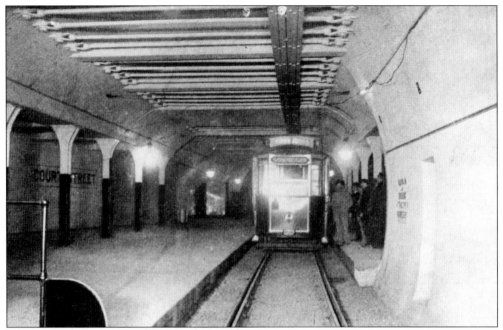

Court Street Station was the last stop on the Boston side of the tunnel before the streetcars reached Maverick Square. Known as the "Blue Line" today, the speedy connection continues on to Orient Heights and Revere Beach.

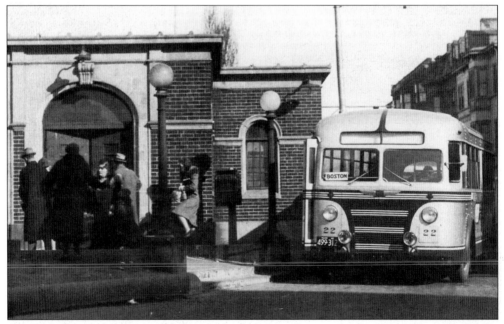

A bus awaits passengers outside the Maverick Square Station in the 1940s. (Courtesy of the BPL)

Looking toward Maverick Square from the corner of Sumner and Seaver Streets, the spire of the Our Lady of the Assumption Church can be seen on the right. (Courtesy of the BPL)

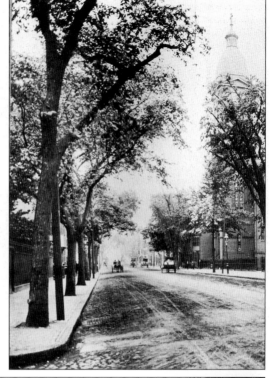

Belmont Park was laid out as a park in the mid-nineteenth century and is bounded by Sumner, Seaver, Webster, and Lamson Streets. Originally known as Camp Hill, it was used as a training field first by the colonists and later by the British. A large boulder with a now lost bronze tablet once proclaimed its history. Three boys relax on a park bench at the turn of the century. (Courtesy of SPNEA)

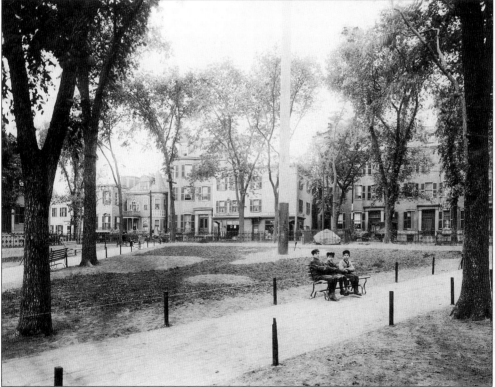

This brick duplex house was built on Webster Street, near Lamson Street, in the 1840s. Typical of the early houses built in East Boston during the first two decades after the East Boston Company was founded in 1833, these houses were set back from the street and had sun blinds on all the windows. (Courtesy of the BPL)

The home of John H. Sullivan, president of the Columbia Trust Company, was built on Webster Street facing Belmont Park. An elegant brick townhouse with an Egyptian Revival entrance and gate posts, its rear windows have unsurpassed views of Boston Harbor.

Three
Central Square

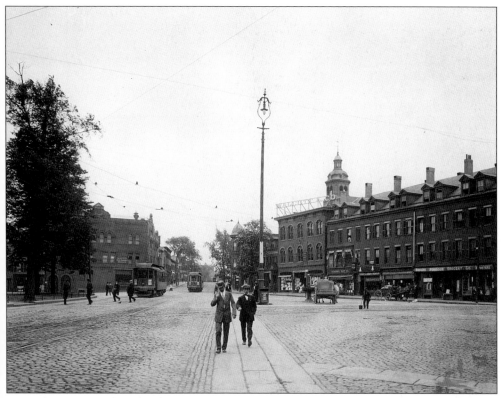

Central Square was literally the center of East Boston when it was laid out by the East Boston Company. The junction of Meridien, Porter, Bennington, Saratoga, Border, and Liverpool Streets, it has a circular tree-shaded park on the left. Streetcars approach Central Square on Meridien Street, and the stores on the right included Walcott & Company, the Central Hat Company, and the Morrison Grocery Company. (Courtesy of SPNEA)

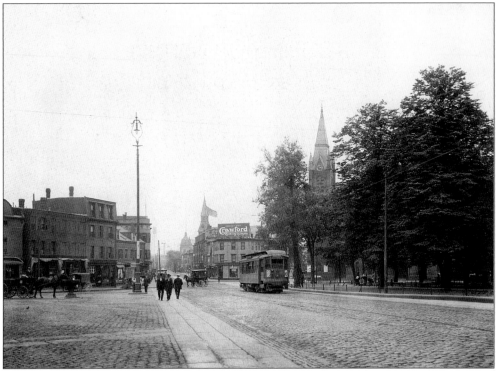

Looking south from Central Square, Meridien Street leads to Maverick Square. A horse drinks from the horse trough on the left and the spire of the Maverick Congregational Church can be seen rising above the trees in the park. (Courtesy of SPNEA)

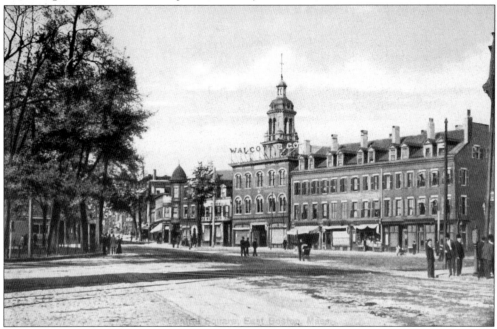

Some of the stores on Porter Street facing Central Square were originally built as townhouses, but they gave way to commercial purposes by the turn of the century.

The location of the second post office in East Boston was in the Stevenson Block, built by Joseph Henry Stevenson at the block facing Central Square between Meridien and Border Streets. Stevenson built many commercial structures and residences, including his home at 41 Princeton Street in East Boston.

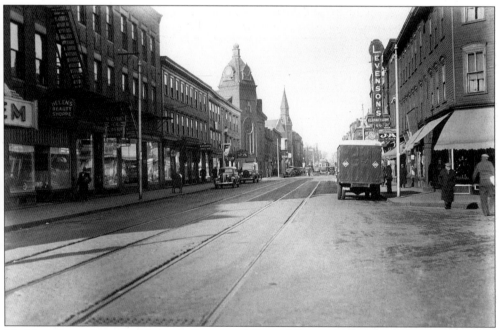

Meridien Street, between Maverick Square and Central Square, had numerous stores, churches, and apartment buildings. On the left is the Gem Theatre; the two churches in the distance are the Methodist Episcopal Bethel at Havre Street and the First Presbyterian Church at London Street. (Courtesy of SPNEA)

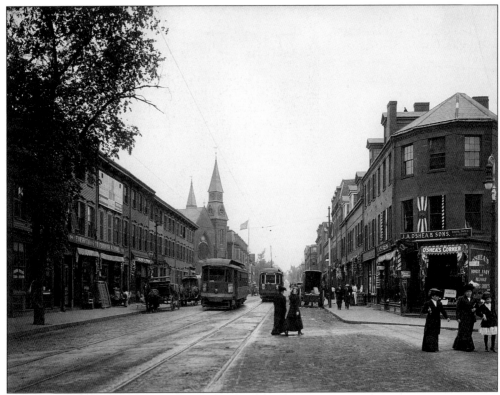

Meridien Street, seen here looking north from the corner of Havre Street, had numerous stores of every description on both sides of the street. (Courtesy of SPNEA)

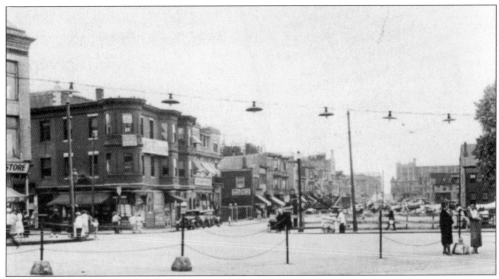

Porter Street, as seen from Central Square in 1933, was a street of shops, stores, and apartment buildings before the entrance to the Sumner and Callahan Tunnels was built. (Courtesy of the East Boston Savings Bank)

Two chums pose on Porter Street in the 1940s. (Courtesy of the East Boston Savings Bank)

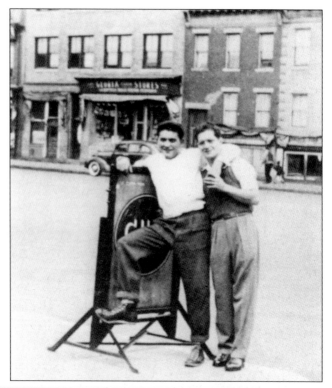

The original Liberty Market was in a small storefront on Porter Street. (Courtesy of the East Boston Savings Bank)

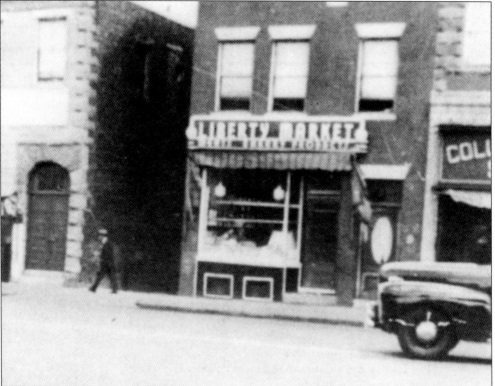

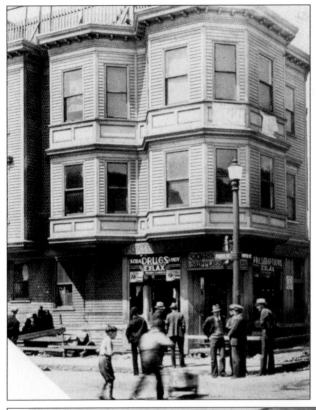

The Porter Pharmacy was located at the corner of Porter and Paris Streets in a building that was demolished in 1933 to make way for the entrance to the Sumner Tunnel. (Courtesy of the East Boston Savings Bank)

These stores on Porter Street were slated for demolition early in 1933 to make way for the Sumner Tunnel. The window sign stated that "All Goods must be sold regardless of cost" before the building was demolished. (Courtesy of the East Boston Savings Bank)

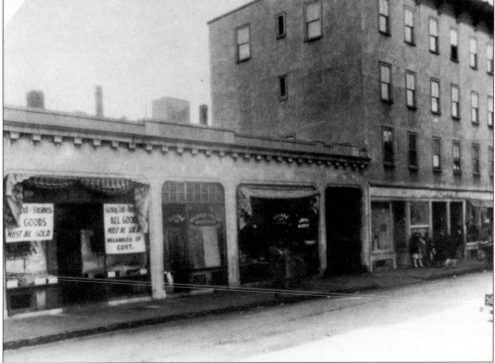

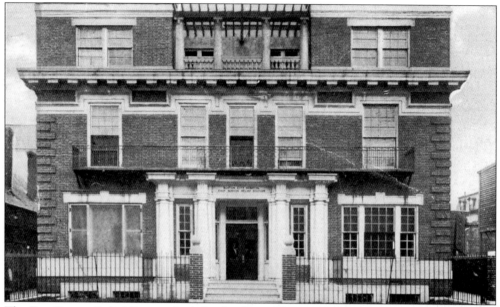

The East Boston Relief Station, built by the City of Boston at the corner of Porter and Havre Streets, offered medical services to residents of the community. The building has recently been restored and is now used as the East Boston Counseling Center.

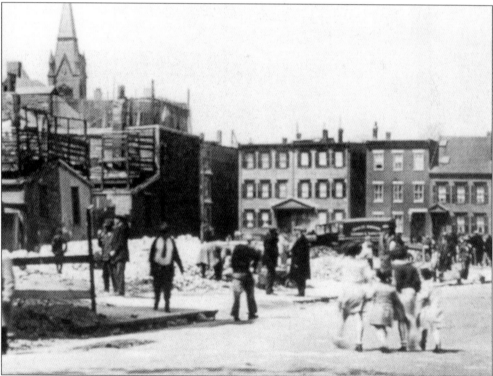

Porter Street, by 1934, had become a rubble-strewn area of houses and stores demolished for the Sumner Tunnel. The spire of the East Boston Unitarian Church is visible rising above the buildings on the left. (Courtesy of the East Boston Savings Bank)

Four men discuss the demolition taking place along Porter Street in 1933. (Courtesy of the East Boston Savings Bank)

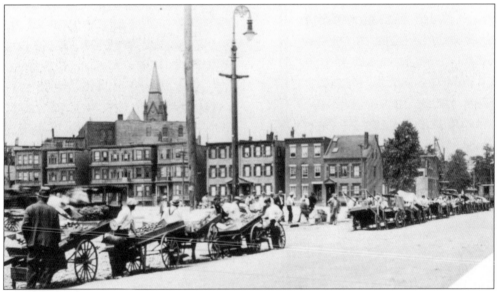

A haymarket was set up along Porter Street by vendors who brought their tipcarts full of produce and vegetables. (Courtesy of the East Boston Savings Bank)

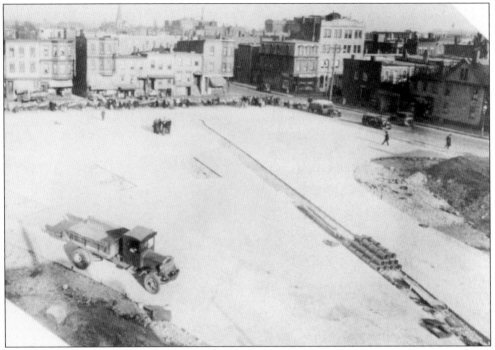

The new toll plaza for the Sumner Tunnel, which was named for William Hyslop Sumner, nears readiness in 1934. The houses on the left front onto Porter Street. (Courtesy of the East Boston Savings Bank)

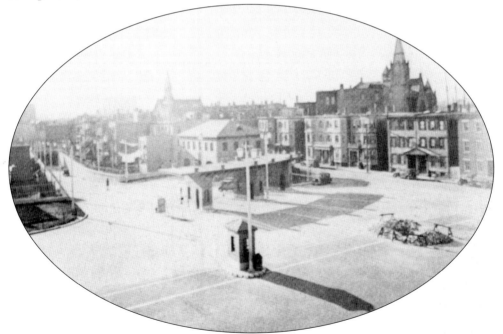

The new toll plaza, with the toll collector's booth, allowed automobiles to pass from East Boston to the North End of Boston via a tunnel that was laid under Boston Harbor. (Courtesy of the East Boston Savings Bank)

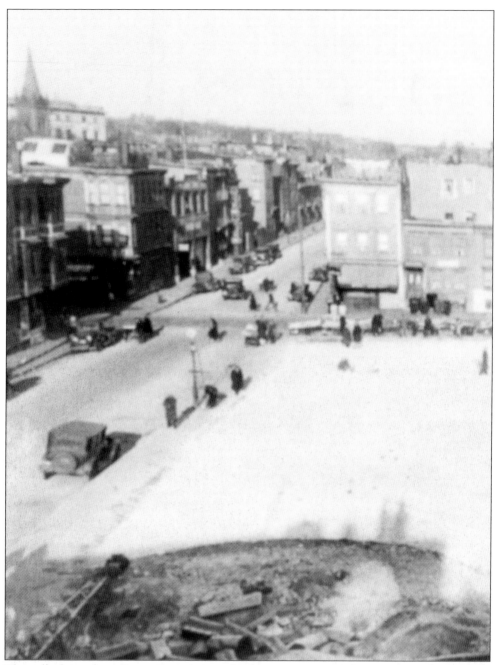

The toll plaza, along Porter Street, created a large open space where stores and apartment houses once stood. The Sumner Tunnel would later be augmented by the building of the Callahan Tunnel after World War II. (Courtesy of the East Boston Savings Bank)

Four
Eagle Hill

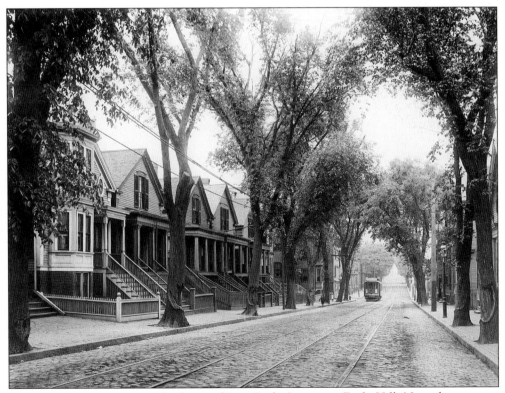

Lexington Street connects Meridien and East Eagle Streets on Eagle Hill. Note the streetcar tracks laid down the center of the street in this turn-of-the-century photograph. (Courtesy of SPNEA)

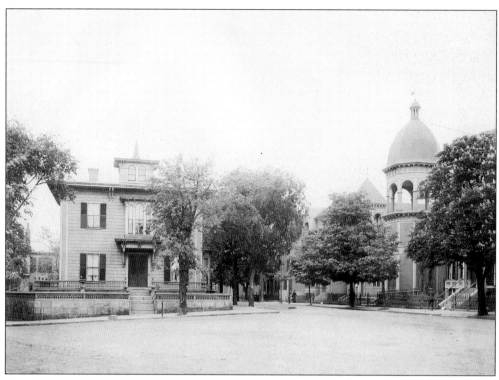

Governor John Lewis Bates lived in this Italianate mansion facing Monmouth Square, the junction of Eutaw and White Streets. The mansion was later used as the Strong Hospital, a private hospital founded by Dr. Strong. On the right is the All Souls Universalist Church, which was founded in 1838 and built at the turn of the century. (Courtesy of SPNEA)

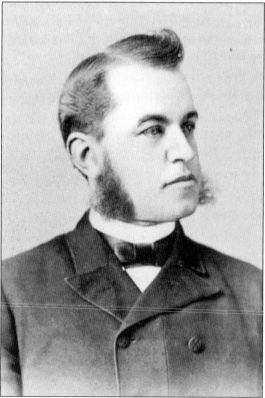

John Lewis Bates served in the Boston Common Council, the House of Representatives, and as governor of Massachusetts. A graduate of Boston University and its law school, he was a president of the East Boston Citizens' Trade Association.

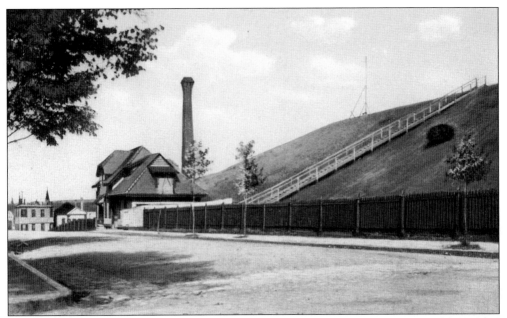

The reservoir in East Boston, a 25,000-gallon basin on an elevated knoll bounded by White, Putnam, Falcon, and Brooks Streets, was flooded on January 1, 1850. A staircase ascends the knoll to the top of the reservoir; this land later became the site of the present East Boston High School in 1928.

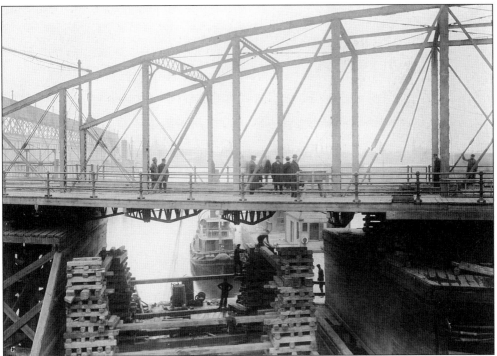

The Chelsea Bridge connected East Boston and Chelsea across the Chelsea Creek. A group of men stand on the bridge as wood risers are floated on a barge under the bridge to begin repairs in 1914. (Courtesy of SPNEA)

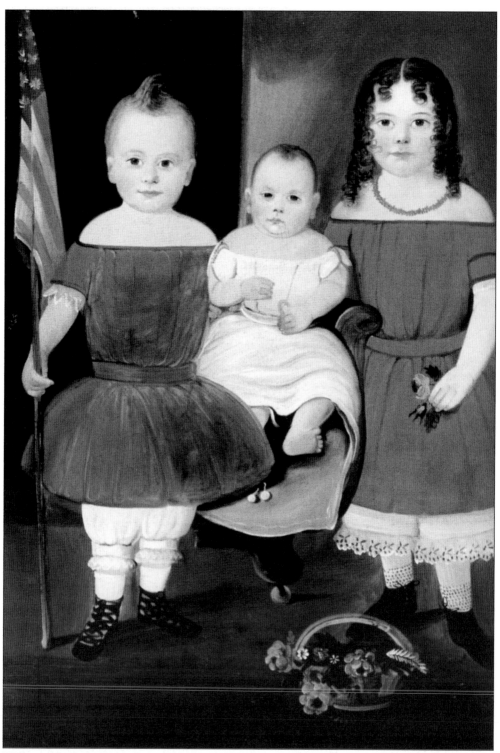

William Matthew Prior painted this portrait of Hattie Elizabeth, Ellis and Eva Flye of Boston at his studio on Trenton Street in East Boston on September 25, 1854.

William Matthew Prior (1806–1873) painted this self portrait in 1825. A noted artist, who considered himself a "fancy, sign and ornamental painter," moved to East Boston from Portland, Maine, in 1841 and settled on Trenton Street on Eagle Hill.

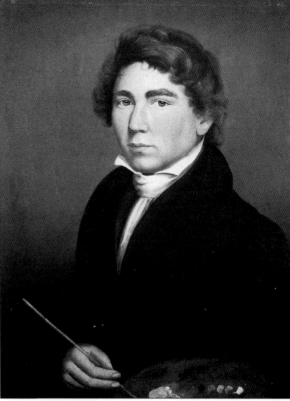

A paper label was often affixed to the reverse of Prior's portraits, stating "Portraits painted in this style done in about an hour's sitting. Price $2.92, including Frame, Glass, &c."

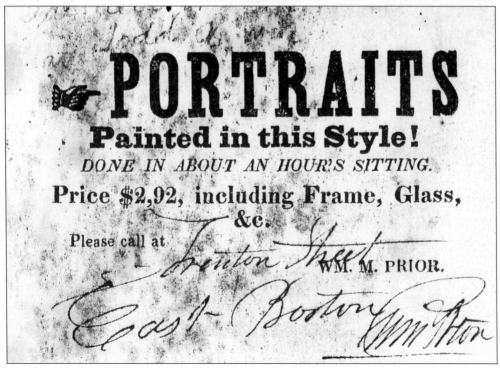

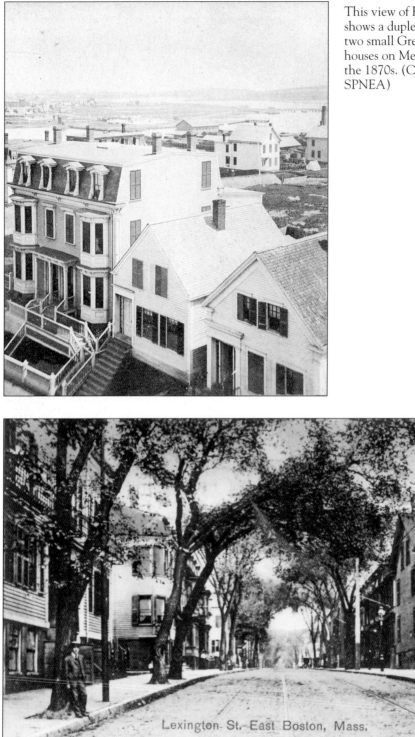

This view of East Boston shows a duplex house and two small Greek Revival houses on Meridien Street in the 1870s. (Courtesy of SPNEA)

Lexington St. East Boston, Mass.

At the turn of the century, Lexington Street had large arching shade trees that offered a bucolic quality to the neighborhood.

A streetcar approaches the corner of Bennington and Prescott Streets. (Courtesy of the East Boston Savings Bank)

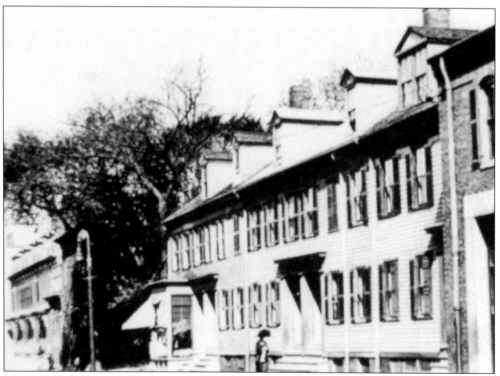

Marion Street, which connects White and Bennington Streets, had small wood-framed row houses on both sides of the street at the turn of the century. (Courtesy of the East Boston Savings Bank)

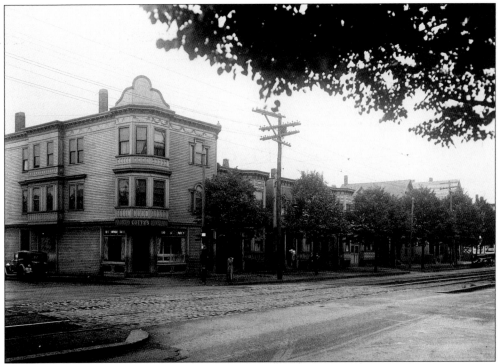

This three decker at the corner of Bennington and Moore Streets was located just past Day Square, and housed Cotty's Bakery on the first floor. The tracks in the foreground were for the streetcars that connected Orient Heights to Boston via Maverick Square. (Courtesy of SPNEA)

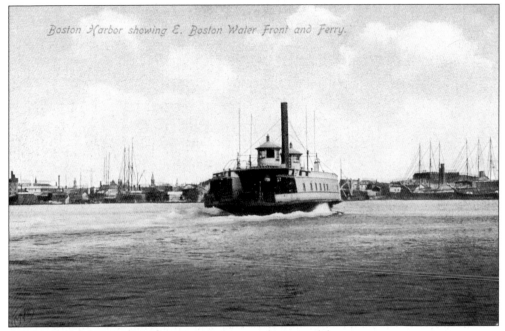

A ferry approaches the East Boston waterfront at the turn of the century.

Five

The Ferries
and the Railroad

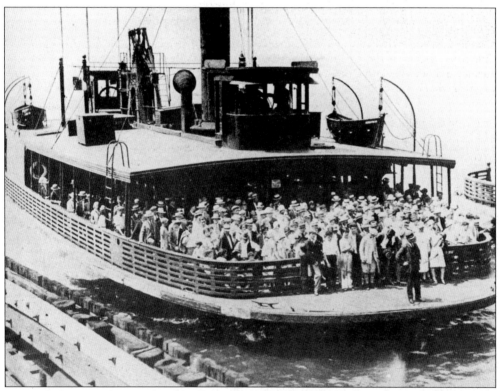

A crowded ferry approaches the East Boston waterfront in the 1920s. The North Ferry left from Battery Wharf on Commercial Street in Boston and docked at Border Street; the South Ferry left from State Street and docked at Lewis Street. Many of the passengers would continue on by train to Revere Beach via the Boston, Revere Beach and Lynn Railroad for an afternoon of amusements and swimming. (Courtesy of the BPL)

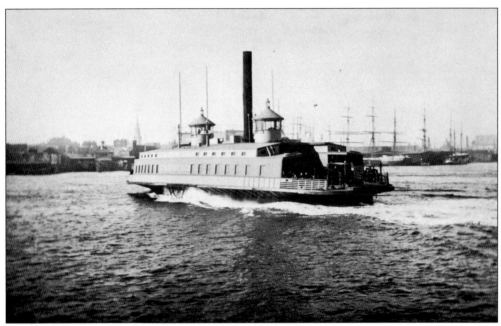

The General Hancock was one of the ferries of the People's Ferry Line, which was founded in 1853 connecting Boston and East Boston. Shown here approaching Lincoln Wharf on the Boston side of the harbor, the ferry was for both passengers and horse-drawn carts.

Thomas Kellough was the superintendent of ferries at the turn of the century. Initially a shipwright in East Boston, he was appointed superintendent in 1895 by Mayor Edward Upton Curtis.

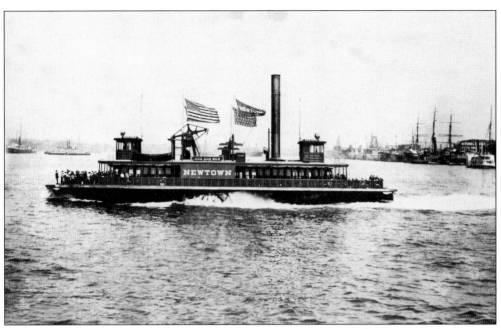

The *Newtown* was built in 1908 and became part of the ferry service that connected passengers to the Boston, Revere Beach and Lynn Railroad. East Boston's waterfront can be seen on the right. (Courtesy of the BPL)

The North Ferry building on the East Boston waterfront was a fanciful waiting station for passengers continuing on to Lynn by train. (Courtesy of Vito Aluia)

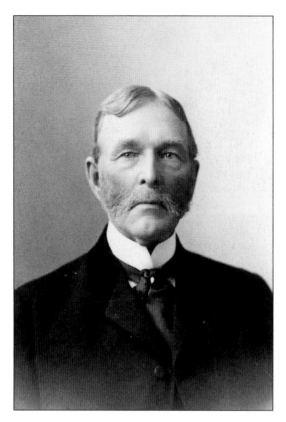

Alpheus Perley Blake was the first president of the Boston, Revere Beach and Lynn Railroad. A successful land developer and the founder of Hyde Park, Massachusetts, Blake founded the narrow gauge railroad in 1875, providing passage at 3¢ a person. (Courtesy of the Hyde Park Historical Society)

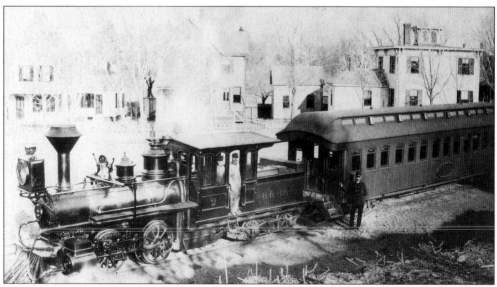

Locomotive #2 was known as the Pegasus and was an engine of the Boston, Revere Beach and Lynn Railroad. Built in 1875 by Mason, it served for two decades until destroyed by fire at Orient Heights in 1896. (Courtesy of the Lynn Historical Society)

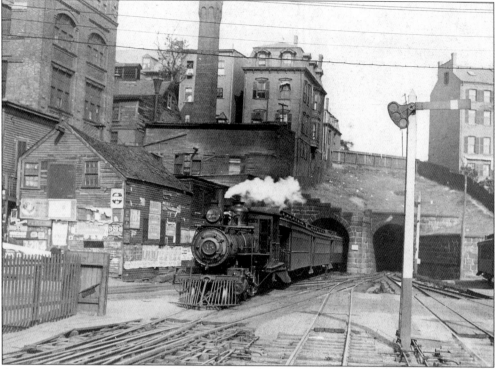

A train passes through the tunnel built under Jeffries Point by the Boston, Revere Beach and Lynn Railroad. The mansard-roofed house above the tunnel is on Sumner Street in East Boston. (Courtesy of the Lynn Historical Society.)

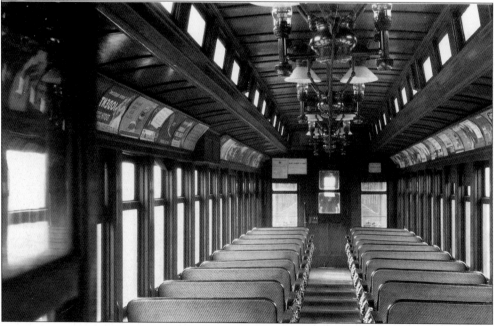

The interior of the railroad cars of the Boston, Revere Beach and Lynn Railroad had oil lamps and straw seats in the late nineteenth century. (Courtesy of the Lynn Historical Society.)

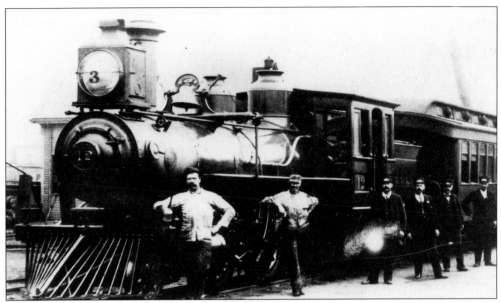

The engineer, his assistant, and conductors pose beside Engine #12 as they await passengers arriving in East Boston from Boston via the ferries. (Courtesy of Lynn Historical Society)

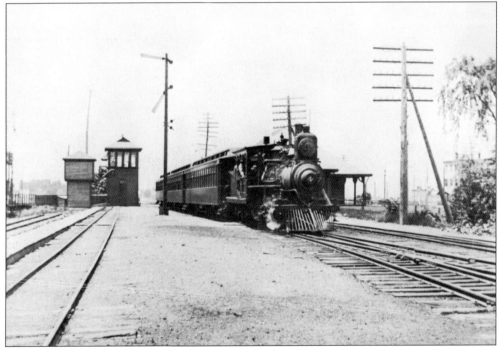

A train of the Boston, Revere Beach and Lynn Railroad leaves Orient Heights in East Boston bound for Winthrop in 1890. (Courtesy of the Lynn Historical Society)

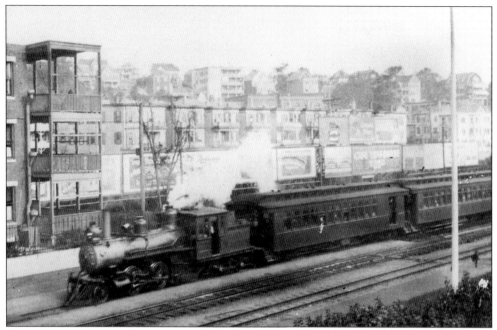

A train gathers speed after having left the station at Orient Height in East Boston. Large billboards line the tracks and the three deckers of Orient Heights can be seen in the distance. (Courtesy of the Lynn Historical Society)

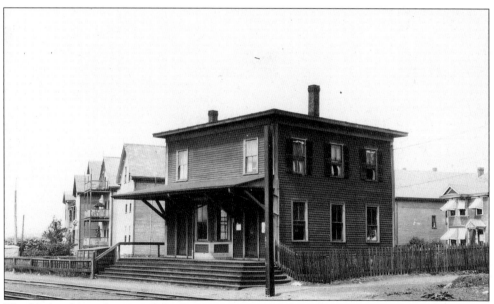

The Harbor View Station of the Boston, Revere Beach and Lynn Railroad line was a small station that literally had a superb view of Boston Harbor. (Courtesy of the Lynn Historical Society)

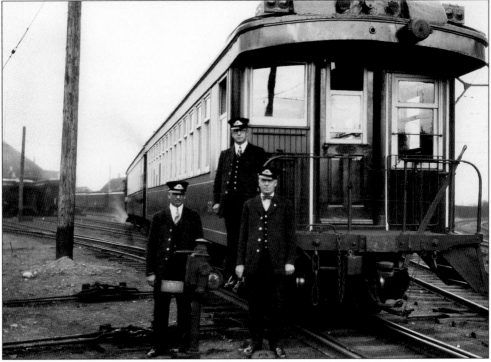

Three conductors pose behind an electrified train of the Boston, Revere Beach and Lynn Railroad in the late 1920s. The line continued until 1940 when it was shut down. (Courtesy of the Lynn Historical Society)

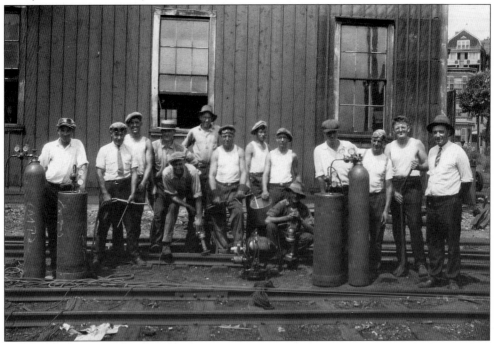

A shop crew of the Boston, Revere Beach and Lynn Railroad poses at Orient Heights in 1920. (Courtesy of the Lynn Historical Society)

Six
Churches

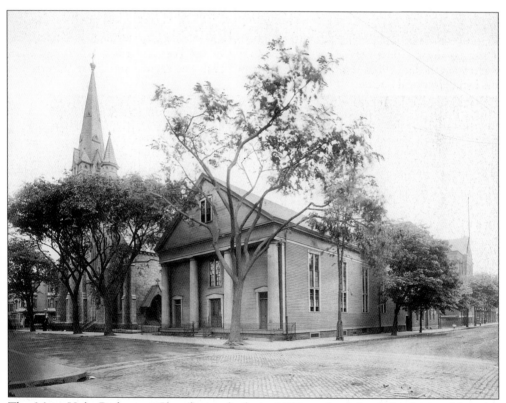

The Most Holy Redeemer Church was built in 1856 to the left of the former Maverick Congregational Church on Maverick Street, between London and Havre Streets. The Greek Revival church was built in 1837 and was sold to the Catholics, who dedicated the church to Saint Nicholas and worshiped there until the granite church was built. (Courtesy of SPNEA)

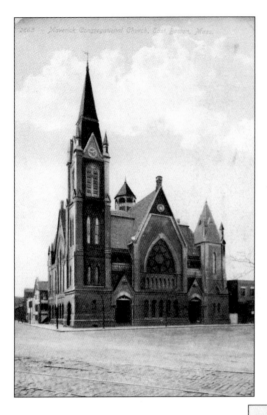

The Maverick Congregational Church built a much larger church in Central Square, now the site of the East Boston Social Center. The oldest religious society in East Boston, it was formed in 1836. The edifice of the new church was a "large and imposing structure of brick, and stands commandingly in Central Square."

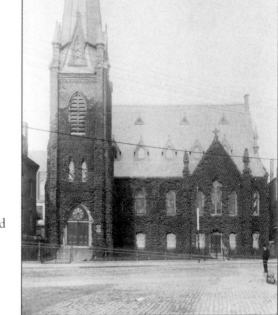

The First Unitarian Church was organized in 1845 at Richie Hall. This church, thought "one of the handsomest and one of the most costly structures of East Boston," was later built on the corner of Maverick and Bremen Streets. (Courtesy of the BPL)

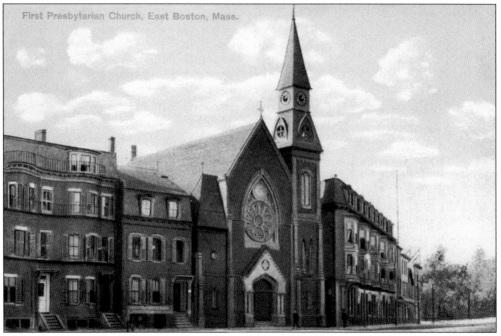

The First Presbyterian Church was founded in 1854. This edifice was built in 1871 on the site of an earlier church destroyed by fire at the corner of Meridien and London Streets.

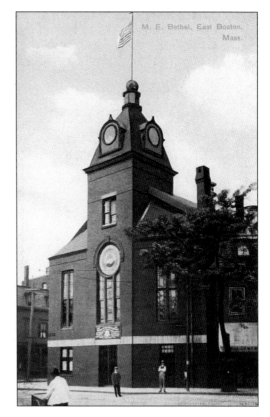

The Methodist Episcopal Bethel was founded in 1842 and is at the corner of Meridien and Decatur Streets. "Father" Taylor, of the Seamen's Bethel in Boston's North Square, preached in East Boston in 1840, which led to the founding of this church.

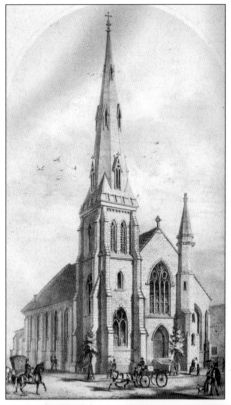

Most Holy Redeemer was designed by Patrick C. Keeley, the foremost catholic architect of the nineteenth century, and "is an imposing stone structure of the thirteenth century design." Dedicated in 1857 by Bishop Fenwick, the use of Rockport granite masonry, a 200-foot-high spire, and seating capacity for 1,100 worshippers made this one of the most impressive churches in Boston.

The nave of the Most Holy Redeemer Church has a vaulted arch ceiling with quatrefoil columns supporting side arches. A glorious rose window is high above a white marble altar that was carved in England by Pugin. (Courtesy of SPNEA)

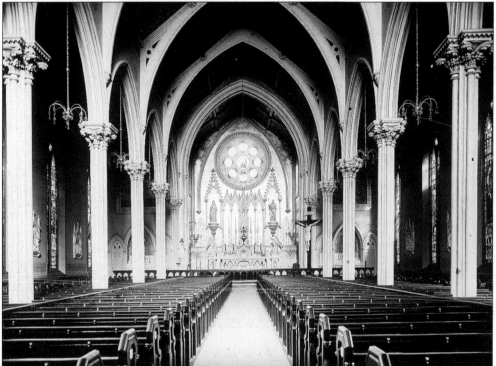

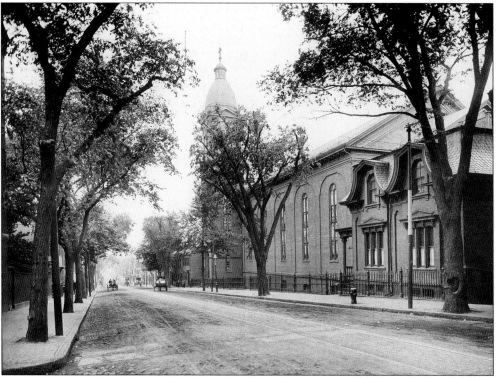

Our Lady of the Assumption, built in 1863 on Sumner Street in Jeffries Point, was also designed by Patrick C. Keeley, as was the rectory, an Italianate cottage with unique bonnet dormers. (Courtesy of SPNEA)

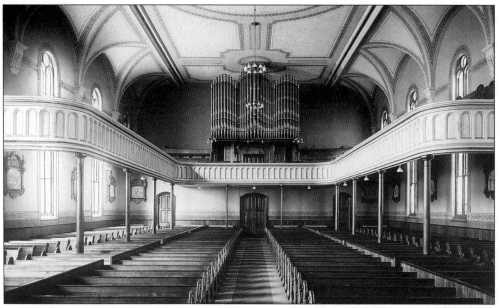

Looking from the altar of Our Lady of the Assumption, the nave was less monumental than that of Most Holy Redeemer. The wind pipes of the organ rise above the gallery in the rear of the church. (Courtesy of SPNEA)

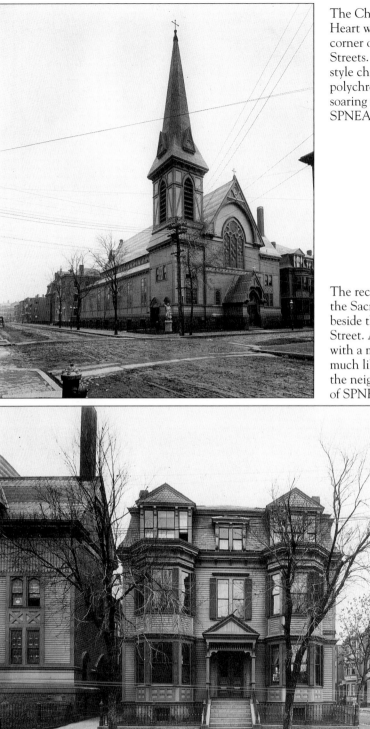

The Church of the Sacred Heart was built in 1873 at the corner of Brooks and Paris Streets. A wood-framed stick-style church, it had a polychromatic slate roof and a soaring spire. (Courtesy of SPNEA)

The rectory of the Church of the Sacred Heart was built beside the church on Brooks Street. A double-bay house with a mansard roof, it was much like the other houses in the neighborhood. (Courtesy of SPNEA)

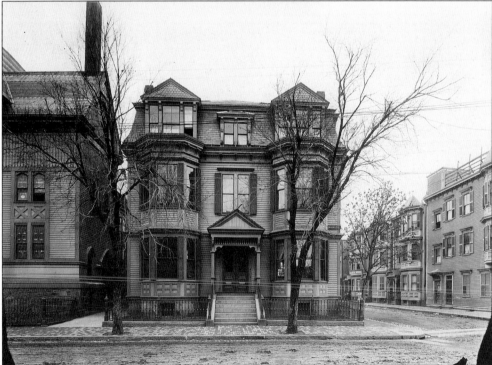

Mary Struzziero was confirmed at the Star of the Sea Church at the corner of Saratoga and Moore Streets in Orient Heights. She poses proudly in her white dress and veil for the photographer. (Courtesy of Kenneth Turino)

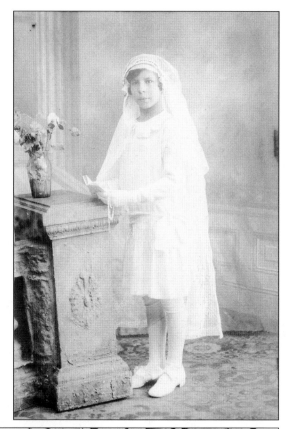

Gilda Pisapia and Joseph Sammarco were married on April 18, 1948, at the Our Lady of Mount Carmel Church on Gove Street. They leave the church followed by Mary Malio, her maid of honor, and Anthony Sammarco, his best man, as family and friends shower the newlyweds with confetti. (Courtesy of the Sammarco Family)

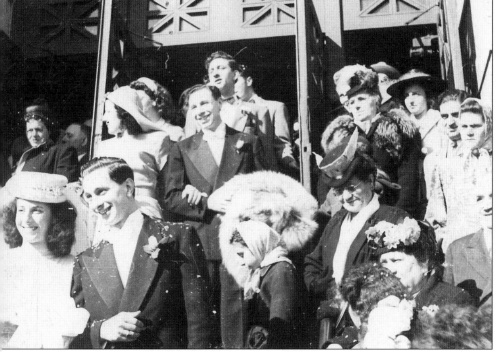

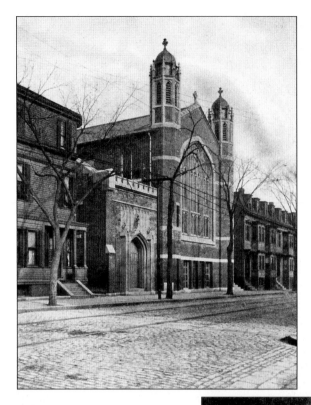

Saint John's Church was built in 1903 on Lexington Street. An impressive Elizabethan Gothic church, it was an Episcopalian church of "working people, by working people, for working people grateful for the gifts which have come to it so richly in recent years."

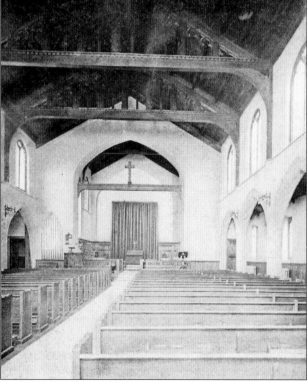

The interior of Saint John's Church was quite simple. Founded in 1850, the original church was located in "low, marshy ground . . . bleak wilderness beyond." East Boston developed throughout the nineteenth century, however, and in 1903 the new church was built in the midst of a thriving neighborhood.

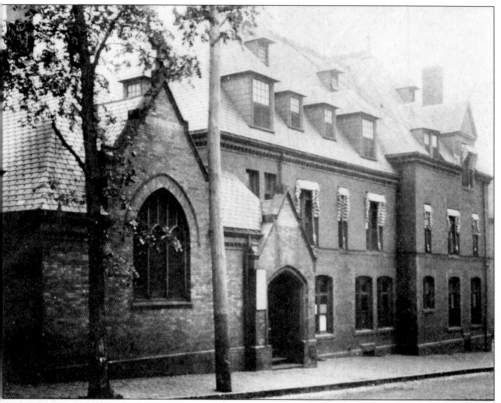

Saint Mary's Church was founded in 1892 and was built at the corner of Marginal and Cottage Streets in Jeffries Point. Serving the sailors who frequented the port, it offered not only religious services but "reading writing, smoking and game rooms, billiard rooms, bath and toilet rooms" for officers and all classes of men on the ships at berth.

Saint Mary's Parish House, located at 185 Webster Street, was where guilds and clubs of the parish had their meetings. A three-story townhouse, it was a busy and ever active house.

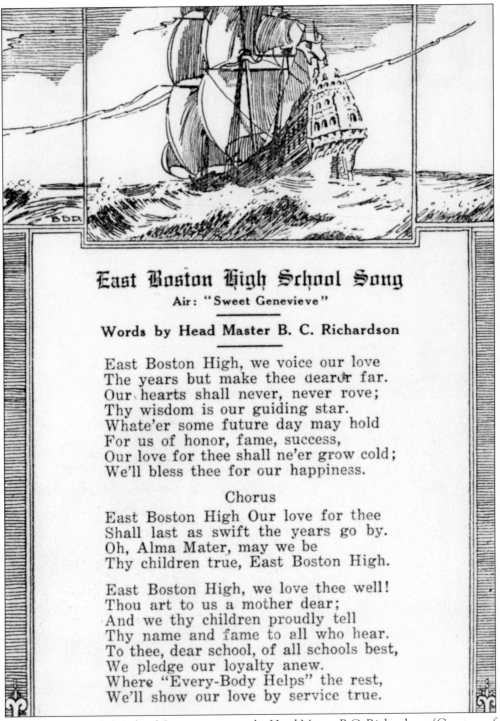

East Boston High School Song
Air: "Sweet Genevieve"

Words by Head Master B. C. Richardson

East Boston High, we voice our love
The years but make thee dearer far.
Our hearts shall never, never rove;
Thy wisdom is our guiding star.
Whate'er some future day may hold
For us of honor, fame, success,
Our love for thee shall ne'er grow cold;
We'll bless thee for our happiness.

Chorus
East Boston High Our love for thee
Shall last as swift the years go by.
Oh, Alma Mater, may we be
Thy children true, East Boston High.

East Boston High, we love thee well!
Thou art to us a mother dear;
And we thy children proudly tell
Thy name and fame to all who hear.
To thee, dear school, of all schools best,
We pledge our loyalty anew.
Where "Every-Body Helps" the rest,
We'll show our love by service true.

The East Boston High School Song was written by Head Master B.C. Richardson. (Courtesy of the BPL)

Seven
Schools

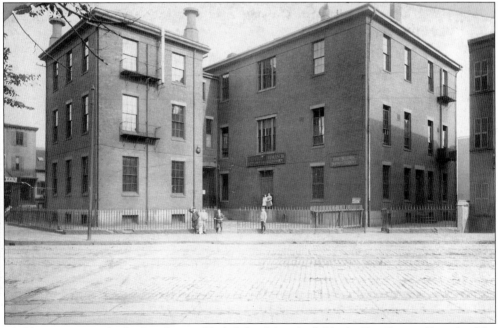

Children pose outside the East Boston High School (on the left), the East Boston Branch of the Boston Public Library, and the East Boston District Court in 1895. (Courtesy of the BPL)

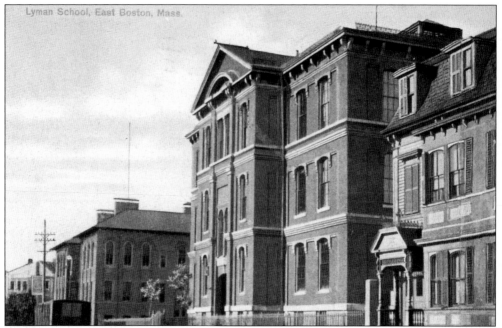

The Lyman School was established in 1837. The present building was designed by the architectural firm of Bryant & Rogers and was built in 1869; it was rebuilt after a fire in 1871, and still stands at the corner of Gove and Paris Streets. The school was named for Theodore Lyman (1792–1849), the mayor of Boston in 1834 and 1835, and has been remodeled for housing.

Looking down Paris Street, the Lyman School can be seen on the right. On the left was Temple Ohel Jacob, one of five Jewish temples in East Boston at the turn of the century. (Courtesy of the East Boston Savings Bank)

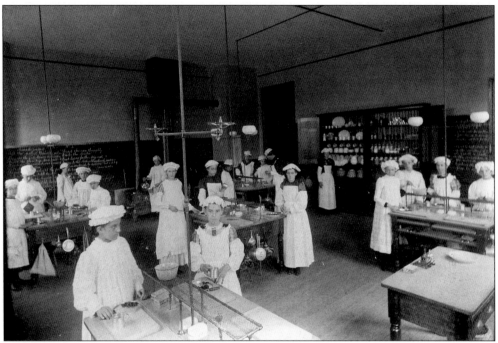

Students at the Lyman School were offered domestic science courses, which were introduced to the Boston school system by Mary Hemmingway and Emily Fifield, members of the Boston School Committee. Girls were taught to cook and bake, and encouraged to try out their recipes at home.

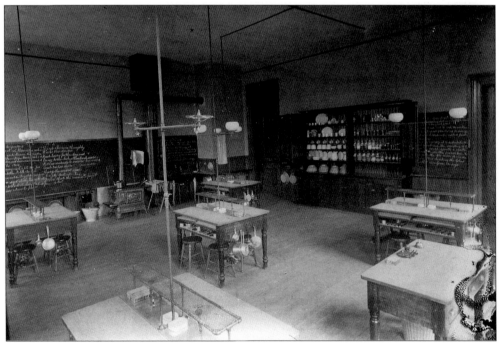

The kitchen in the basement of the Lyman School was well equipped for students to prepare breads and cakes and bake them in the ovens.

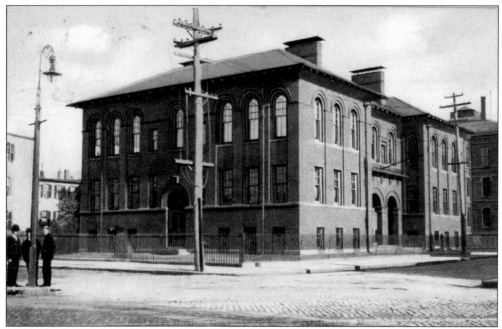

The East Boston Grammar School, known later as the Cudworth School, was on Gove Street, near the Lyman School. The school was named for Reverend Warren Cudworth, pastor of the East Boston Unitarian Church.

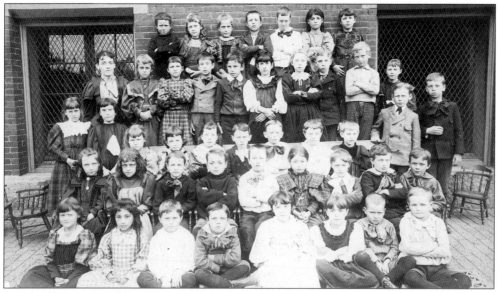

Miss Ray's room at the Princeton Grammar School posed for their class picture in 1896. (Courtesy of the BPL)

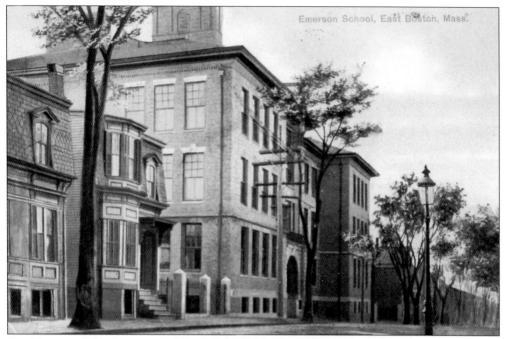

The Emerson School was named for Ralph Waldo Emerson (1803–1882), an author and poet who became an important part of the literary life in Boston during the nineteenth century.

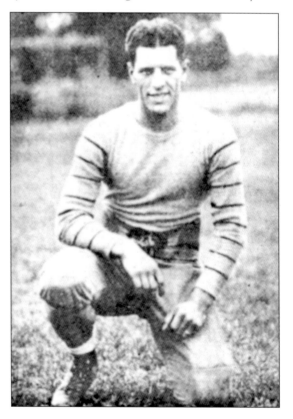

A member of the football team at East Boston High School poses on the field during halftime. (Courtesy of the East Boston Savings Bank)

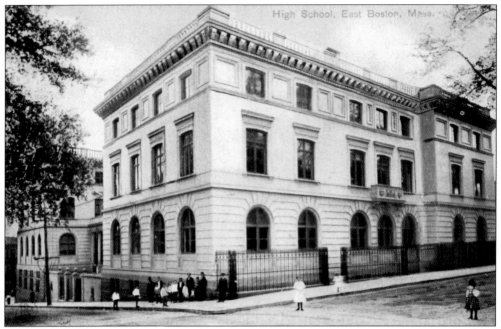

The second building of the East Boston High School was designed by John Lyman Faxon and built in 1901 on Marion Street. After the present East Boston High School on White Street was built in 1926, this building was renamed the Joseph H. Barnes School in honor of a local boy who organized Company K of the 129th Regiment of Massachusetts Volunteers during the Civil War.

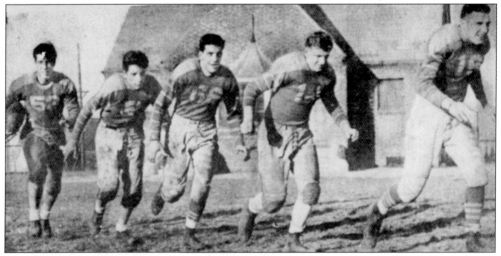

The Noddle Islanders, the East Boston High School football team, jog onto the field before a football game in 1940. (Courtesy of the East Boston Savings Bank)

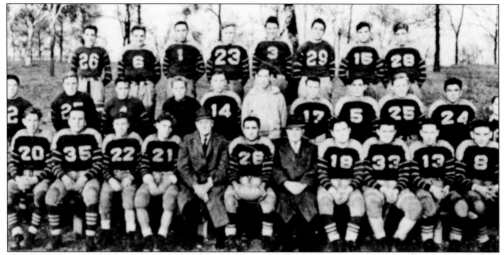

The members of the East Boston High School football team pose with their coaches in 1941. (Courtesy of the East Boston Savings Bank)

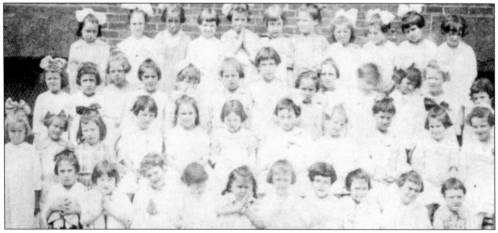

First-grade students at Saint Mary's pose for their class portrait in 1918. Saint Mary's Parochial School was at the corner of Saratoga and Moore Streets in Orient Heights. (Courtesy of the East Boston Savings Bank)

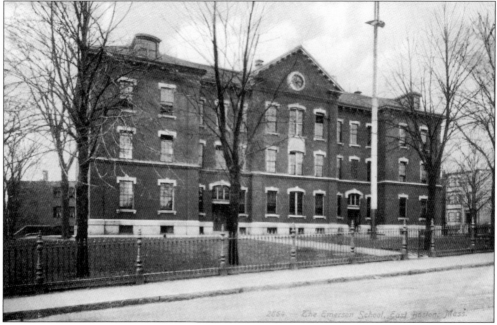

The Emerson School was an impressive brick grammar school that served three generations of East Boston's schoolchildren.

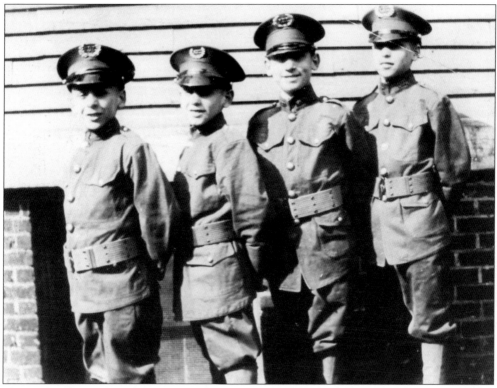

These schoolboy cadets of the Fitton School pose in 1925 on Maverick Street. From left to right are John Penta, Ralph Penta, Edward Palladino, and Ernest Penta. (Courtesy of John Penta.)

Eight
Orient Heights

Two boys pose on Bayswater Street in Orient Heights looking from the Saratoga Street Bridge. In the distance can be seen Winthrop, Massachusetts.

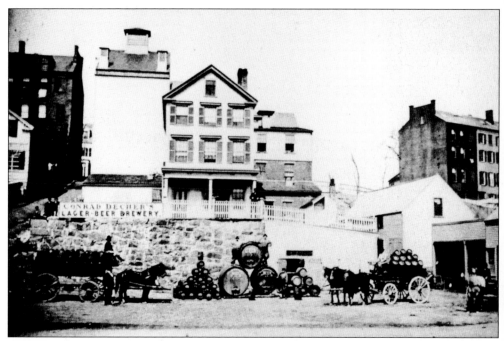

The Conrad Decker Lager Beer Brewery was one of many diverse businesses attracted to East Boston in the nineteenth century. A horse-drawn wagon is piled high with kegs of lager awaiting delivery and a man stands on top of an enormous barrel filled with the precious brew. (Courtesy of the BPL)

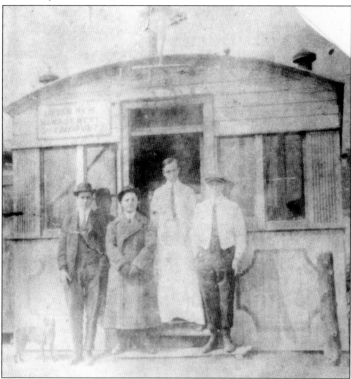

A group of men pose outside a lunch cart that was "Under New Management" and was set on wood pilings at the head of Breed Street in 1918. (Courtesy of the East Boston Savings Bank)

Breed's Hill, named for owner John Breed of Charlestown, could be seen from the Saratoga Street Bridge, and was open land at the turn of the century. The land was later laid out with Ashley, Leyden, and Gladstone Streets and Orient, Montmorenci, Beachview, Faywood, and Waldemar Avenues. A horse and carriage passes Breed Street in front of a lunch cart.

Curtis Street, seen from Saratoga Street, extends from Chaucer to Bennington Streets. Wood Island Park can be seen in the distance.

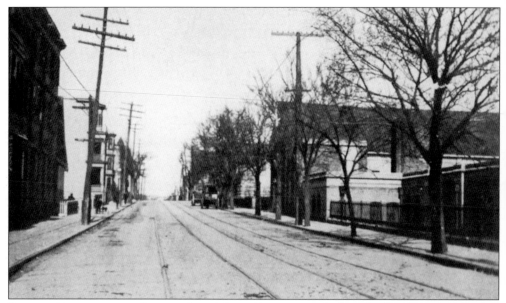

Saratoga Street, seen to the east from Moore Street, once had tracks for the streetcars that connected Orient Heights to Boston via Maverick Square, until they were moved to Bennington Street by the Boston Elevated Railway.

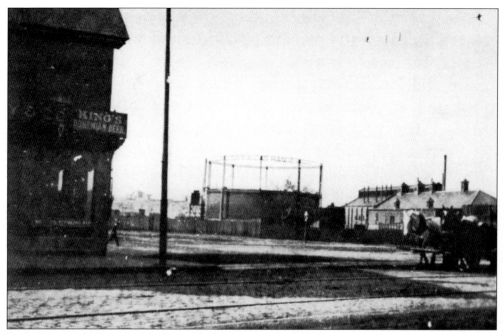

Eagle Square, looking north from Chelsea Street, had King's Tavern on the left and a gas storage tank in the distance.

Ford Street, looking north from Saratoga Street, had been built up with apartment buildings and three deckers by the turn of the century.

Austin Avenue, looking north from Saratoga Street, had well-built three deckers on both sides of the street.

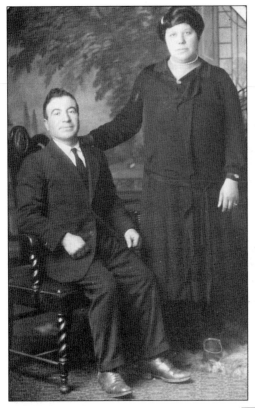

Ermino and Ernestine Struzziero immigrated from Taurasi in the Avellino province of Italy. After their marriage they initially lived on Webster Street in Jeffries Point, and later moved to Neptune Road in Orient Heights. (Courtesy of Kenneth Turino)

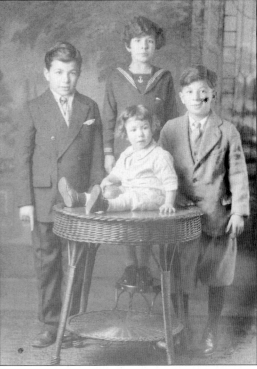

The children of Ermino and Ernestine Struzziero were photographed in 1928. Little Anthony sits on a wicker table and is surrounded by Ernest, Mary, and Al Struzziero. (Courtesy of Kenneth Turino)

Mary Struzziero poses on a pony in front of her home on Neptune Road in Orient Heights. A photographer would often entice parents to have their children's photographs taken while sitting on the gentle and ever-patient pony. (Courtesy of Kenneth Turino)

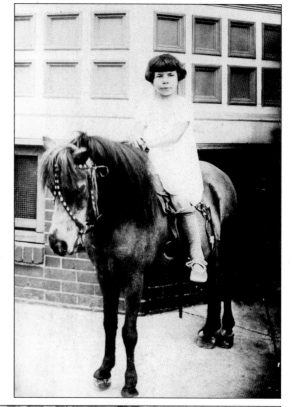

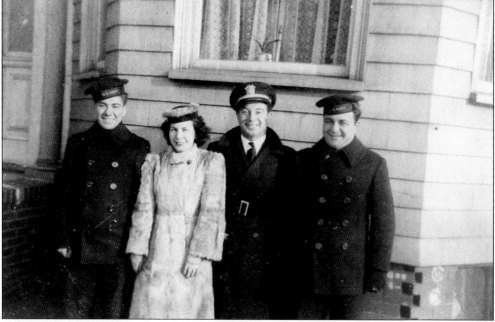

Standing in front of their home on Neptune Road while on leave during World War II are the Struzziero brothers and their sister; from left to right are Anthony, Mary, Al, and Ernest Struzziero. (Courtesy of Kenneth Turino)

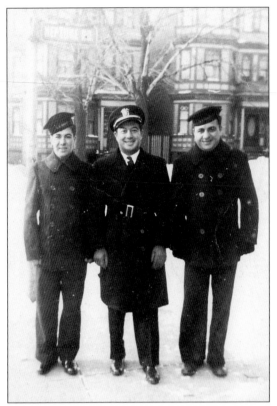

Anthony, Al, and Ernest Struzziero pose on Neptune Road during World War II. This area in Orient Heights was occupied by Irish families at the turn of the century, but by the 1920s, the area and most of East Boston was predominantly Italian. (Kenneth Turino)

This East Boston football team, "The Neptunes," posed behind the army barracks at Wood Island Park in 1942. (Courtesy of the East Boston Savings Bank.)

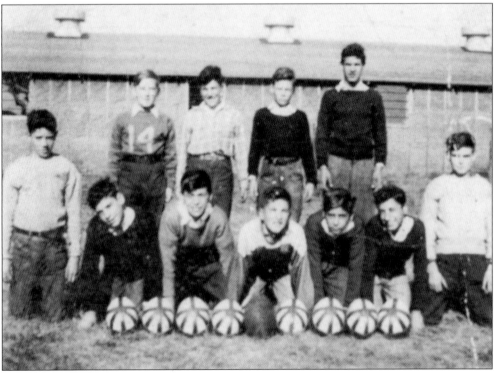

Nine
Wood Island Park
and Logan Airport

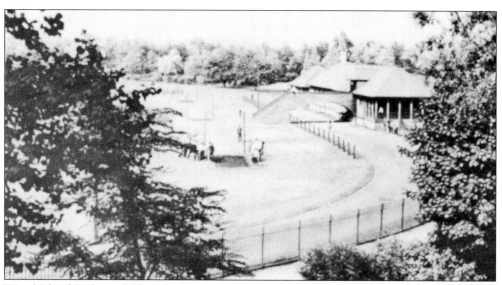

Wood Island Park was laid out by landscape architect Frederick Law Olmstead (1822–1903) in 1898 as a multi-purpose park with tennis courts, a foot-race track, a bathhouse, picnic areas, and a public beach overlooking Boston Harbor. The Gymnasium (on the right) was a large building open to all residents free of charge; in the foreground is a portion of the race track. After World War I, the park was renamed the World War Memorial Park.

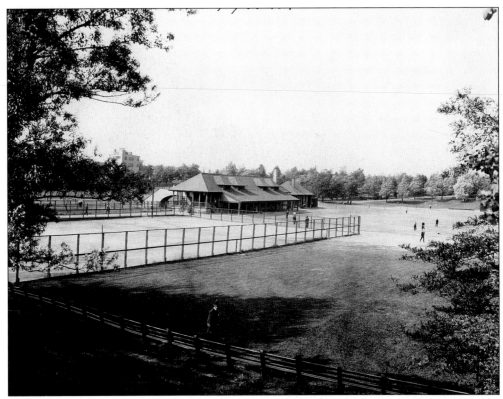

The tennis courts and the Gymnasium, seen from the rear, were not only popular attractions to Wood Island Park, but were heavily used by residents for recreational enjoyment. A policeman walks past the wood benches in the foreground. (Courtesy of SPNEA)

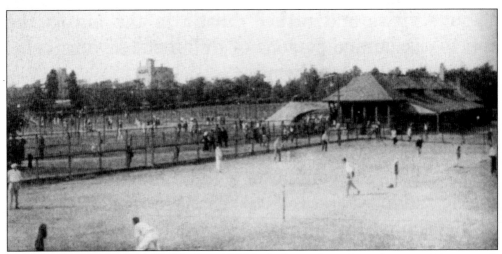

A tennis match at Wood Island Park in 1907 had players dressed in whites as visitors watch from a fence near the Gymnasium.

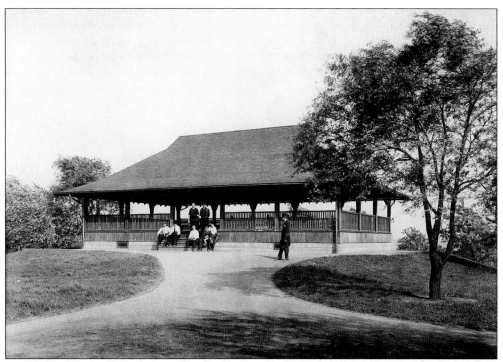

The Shelter House at Wood Island Park did indeed offer shelter during a rainstorm, but it also offered panoramic views of Boston Harbor from the wide porch. A group of men and boys pose on the stairs about 1910. (Courtesy of SPNEA)

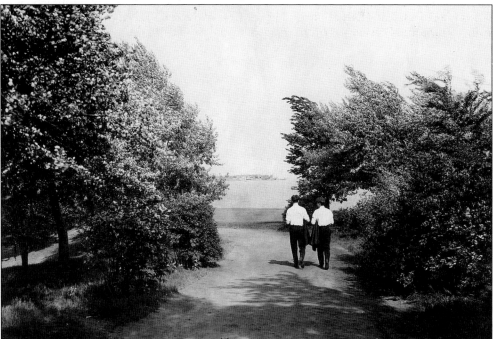

Two boys doff their jackets as they walk down the main walk, east at Wood Island Park. The harbor can be seen through the trees in the distance. (Courtesy of SPNEA)

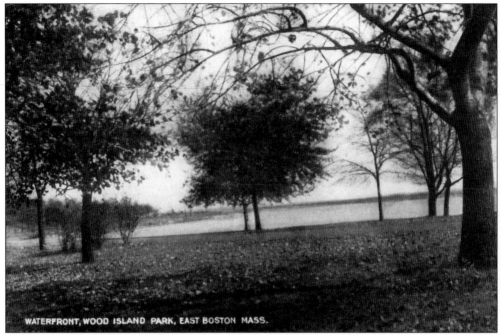

WATERFRONT, WOOD ISLAND PARK, EAST BOSTON MASS.

The waterfront at Wood Island Park had tree-shaded lawns and walks that offered views toward the outer islands and the harbor. It has been said that "Olmstead found landscape art in America at a low ebb" and he "transmuted it into a living force."

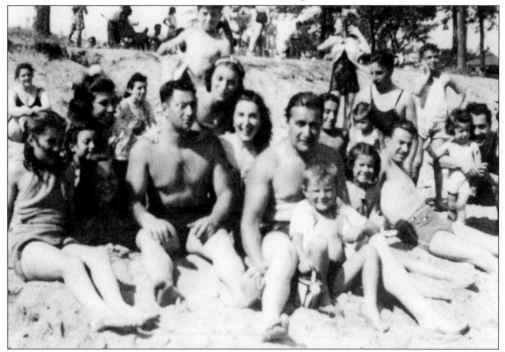

A group of beach-goers sunbathe at Wood Island Park in the 1940s. A Sunday afternoon at Wood Island would often include a cookout and an afternoon of swimming, sand-strewn blankets, and sunburns. (Courtesy of the East Boston Savings Bank)

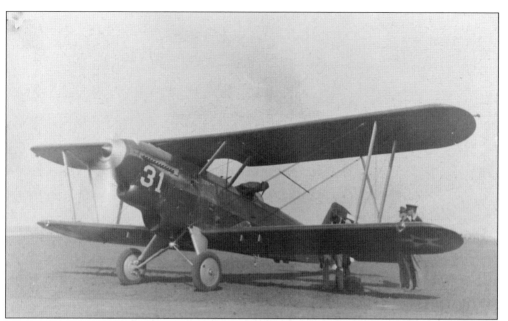

A portion of Wood Island Park was taken for the Boston Municipal Airport in 1922. After one year of construction "the airfield was a 189-acre cinder patch, with two landing strips and three hangers." A two-seater "Douglas," with a 600-horsepower Curtiss Conqueror motor, is shown here at the airport in 1932.

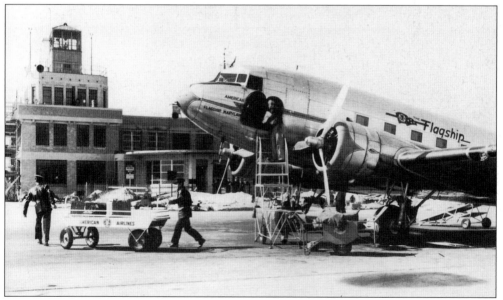

An airplane of the Flagship Line arrives at Logan Airport in 1952 as two porters unload luggage from the cargo hold. The airport was named for Edward L. Logan, a native of South Boston, Massachusetts, and commander of the Yankee Division's 101st Regiment of Infantry during World War I.

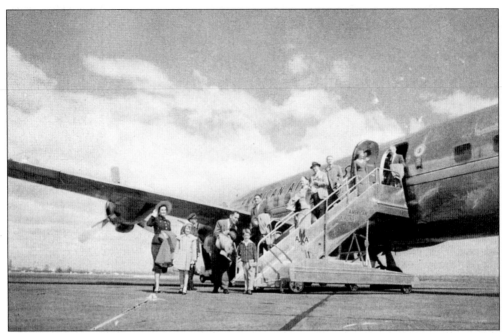

An airplane of American Airlines is parked on the runway as passengers disembark in 1956. The portable steps would allow passengers to disembark directly on the runway rather than via enclosed passages as done today.

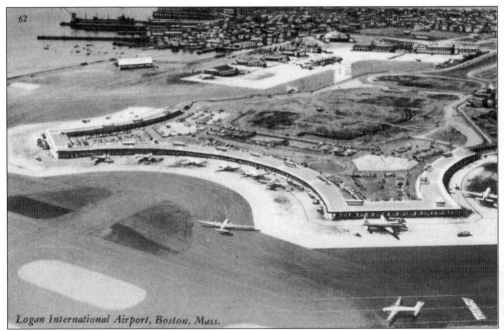

Logan International Airport, Boston, Mass.

Logan International Airport was photographed from the air in 1960. The former Wood Island Park had been sacrificed to airport expansion in 1968; Massport also bulldozed houses along Neptune Road to allow for the massive expansion.

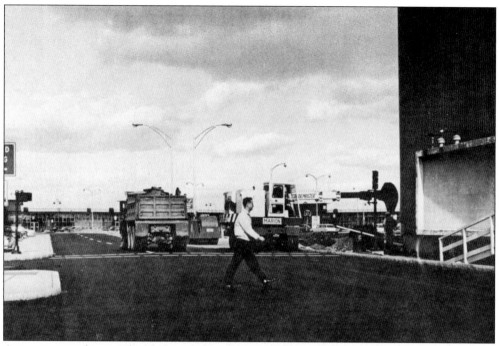

A man crosses the new double-barreled roadway at Logan Airport in 1968.

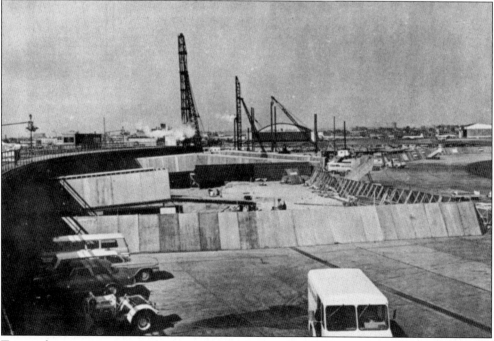

Tremendous construction took place at Logan International Airport throughout the 1960s. A construction project for a new terminal was begun in 1968, and overhead cranes work in the area in front of the American Airlines terminal.

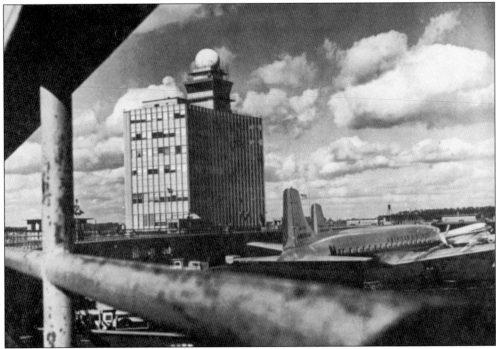

The control tower at Logan International Airport was a highrise building where traffic control at the airport guided both takeoffs and landings.

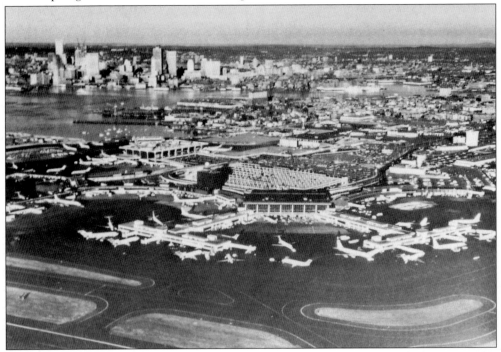

By 1976, Logan International Airport had quadrupled in size since it was laid out in 1928; today, it represents two-thirds of the land in East Boston. Jets park at their terminals as Boston's downtown rises across the harbor.

Ten

The Clipper Ships

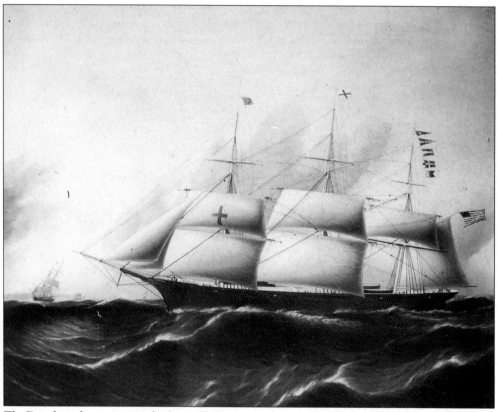

The Dreadnought, a painting by James E. Butterworth, captures what could be considered to be the quintessential clipper ship of the mid-nineteenth century. With its sails furled and its rigging drawn tight, the glamour of the Clipper Ship era is evident in this majestic marine painting. (Courtesy of the BPL)

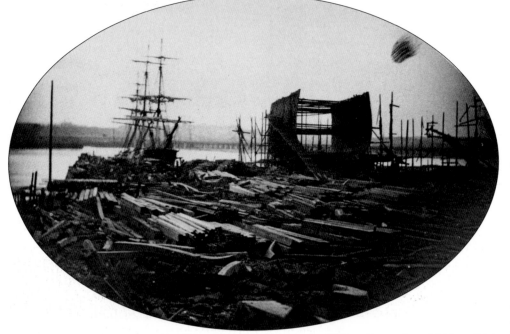

Donald McKay (1810–1880) had been urged to move his shipyard from Newburyport to East Boston by Enoch Train, who said "You must come to Boston; we need you, and if you want any financial assistance in establishing a shipyard let me know the amount and you shall have it." Once he did relocate, the ships McKay crafted in his shipyard on Border Street were thought to have been the sleekest and fastest ships afloat. Skilled as a shipbuilder, Donald McKay was always considered a thorough gentleman by all who knew him.

Donald McKay's shipyards were on Border Street at the foot of White Street from 1844 until his retirement in 1877. The hull of a clipper ship rises on the right, while in the foreground wood planking is being stacked at the ever-active shipyard. (Courtesy of the East Boston Savings Bank)

Enoch Train (1801–1868) was a well-respected, generous, and public-spirited merchant and founder of the White Diamond Line in 1844. His ships, most of which were built by Donald McKay, directly competed with the Cunard Line in the Boston and Liverpool run.

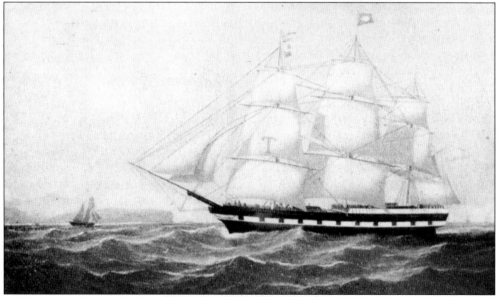

The *Boston Packet Parliament* was built in 1849 by Donald McKay for the Train Line. With a large red T on the foresail and a red pennant bearing a white diamond flying from the center mast, Train's ships were part of his "White Diamond Line"; they crossed the Atlantic Ocean connecting East Boston and Liverpool, England, in competition with those of Sir Samuel Cunard.

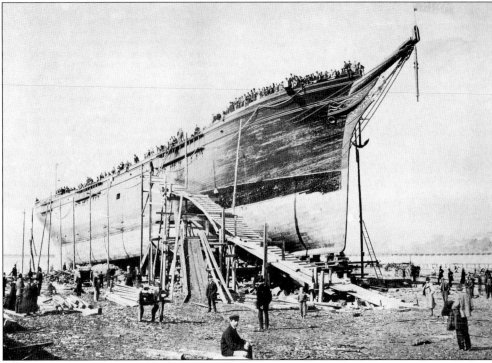

The *Glory of the Seas* was built in 1869 by Donald McKay, who wears a top hat as he gazes up at the ship. Built on speculation, the *Glory of the Seas* continued in service until 1923, but was unfortunately the last clipper ship built by McKay at his shipyard in East Boston. (Courtesy of the BPL).

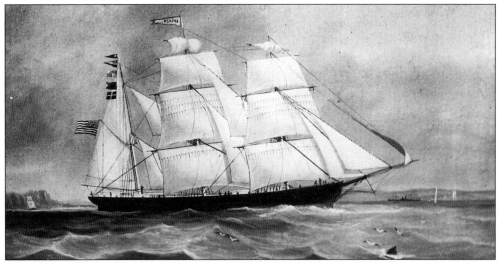

The *Sovereign of the Seas*, built in 1852 by McKay for himself, was one of McKay's fastest clipper ships, rivaling the *Flying Cloud*. He placed her in the command of his brother, Lauchland McKay, and sold her to British shipowners after two successful voyages. From the *Akbar*, launched in 1839 by Samuel Hall from his shipyard in East Boston, to the *Wide Awake* and the *Voyageur de la Mer*, launched in 1857 as the first iron steamships in the United States, East Boston proved it had become a major shipbuilding community.

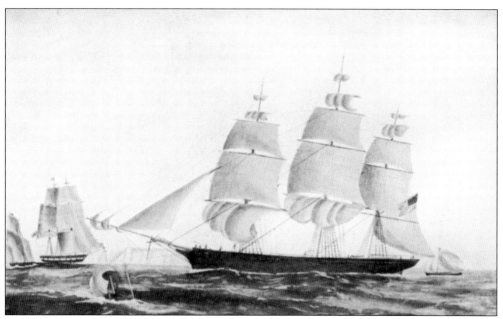

The clipper ship *Surprise*, built in 1852 by Samuel Hall, was painted by a marine artist while in the English Channel.

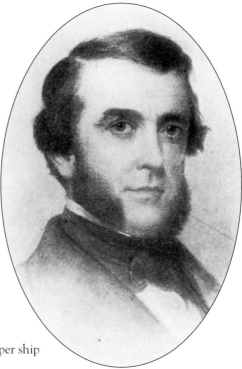

Captain Philip Dumaresq was master of the clipper ship *Surprise*, and later the *Romance of the Seas*.

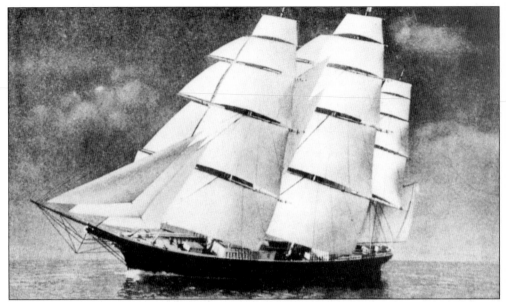

The *Flying Cloud* was a fast traveling clipper ship built in 1851. On her maiden voyage she made the run from New York to San Francisco in eighty-nine days, setting a new record for speed; at one point she ran 374 miles in a twenty-four-hour period. Her feat immediately brought worldwide fame to East Boston and the clipper ships built there by Donald McKay. The *Flying Cloud* was sold by Enoch Train to Grinnell, Minturn & Company of New York for $90,000.

Captain Josiah Perkins Cressy was master of the *Flying Cloud* on her record-setting maiden voyage. Cressey's handling of the ship "astonished all nautical men, and immediately gave a world wide fame to East Boston clippers."

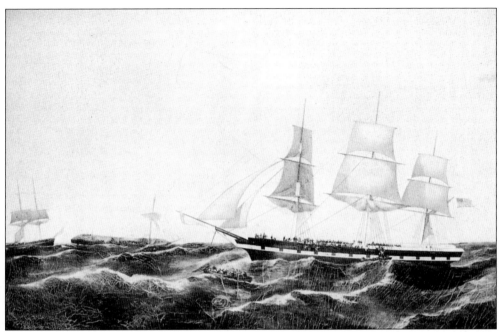

The packet ship *Daniel Webster*, built in 1850, was painted rescuing the emigrant ship *Unicorn*. Named for the great statesman, it was one of twenty-four clipper ships built by Donald McKay for the Train Line.

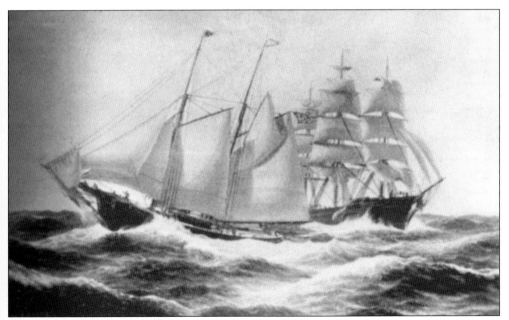

The *Golden Fleece*, built in 1852 by Paul Curtis, and the yacht *Vista* pass on a surging Atlantic Ocean in this painting by John E.C. Peterson.

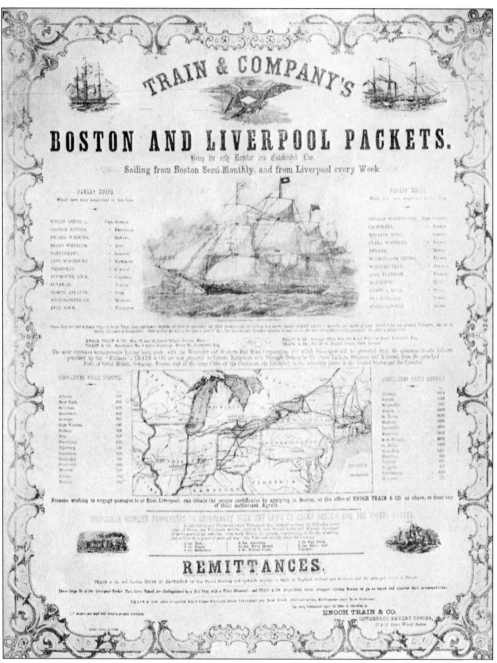

Train & Company's Boston and Liverpool Packets were advertised as "Sailing from Boston semi-monthly and from Liverpool every week." Once the immigrants arrived, Train & Company "went into the through-fare business, advertising in Europe low fares to the interior of America. The line also did a business of up to one million dollars a year in forwarding remittances from the immigrants to their families in Europe."

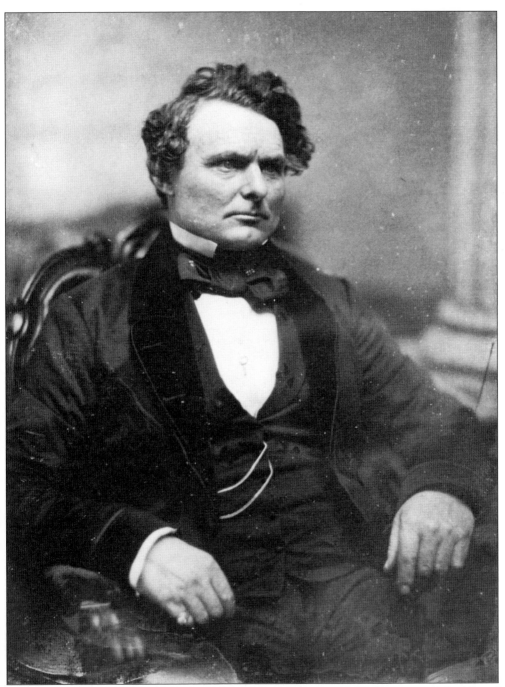

Donald McKay is considered to have been the most outstanding designer and builder of American clipper ships. Photographed in the late 1860s, he was a successful and handsome man whose stern visage made his shipyards on Border Street in East Boston known throughout the world. His mansion still stands at 80 White Street on Eagle Hill, testimony to his success as a shipbuilder. (Courtesy of the BPL)

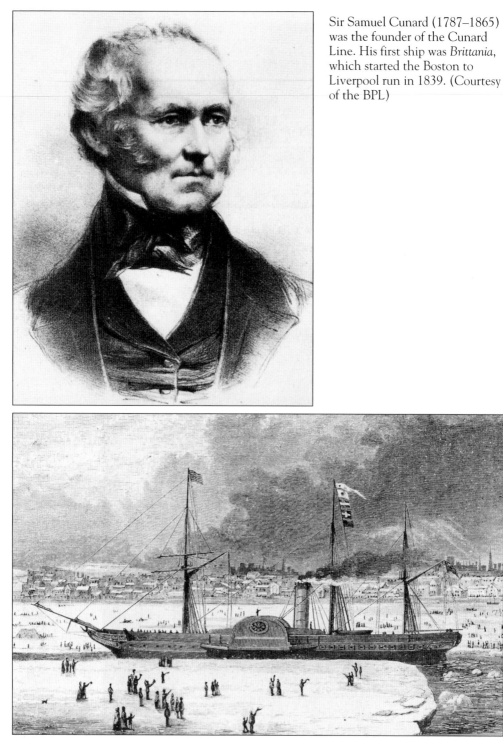

Sir Samuel Cunard (1787–1865) was the founder of the Cunard Line. His first ship was *Brittania*, which started the Boston to Liverpool run in 1839. (Courtesy of the BPL)

The *Brittania* was icebound in Boston Harbor in the winter of 1844. To ensure that Cunard did not shift his operation to New York, the merchants of Boston had icecutters specially cut a passage for the ship so the run could be made without delay. (Courtesy of the BPL)

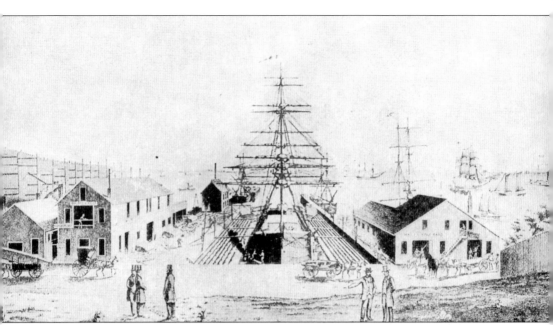

Simpson's Patent Dry Dock was opened in 1854 on Marginal Street in East Boston. The ship *Southern Cross*, owned by Baker & Morrell and built at Briggs Brothers in South Boston, is shown here in dry dock while the underside of her hull is repaired.

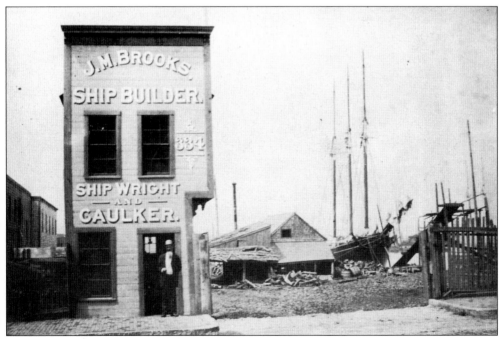

John M. Brooks, a noted shipbuilder, shipwright, and caulker, stands in the doorway of his office at 334 Border Street. His shipyard was once a part of McKay's, where he served as a foreman. (Courtesy of the BPL)

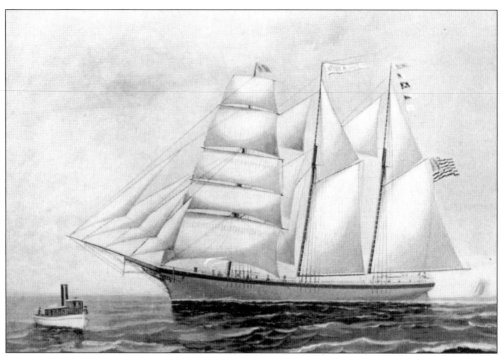

The barkentine *Nellie M. Slade* was the first ship built by Robert Crosbie & Son at their shipyard on Sumner Street in East Boston.

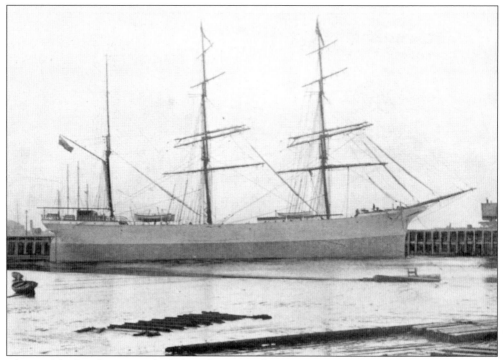

The steel bark *Belmont* was built by John G. Hall & Company of East Boston and was 1,417 tons. Hall built the first steel-hulled ship in this country at his shipyard.

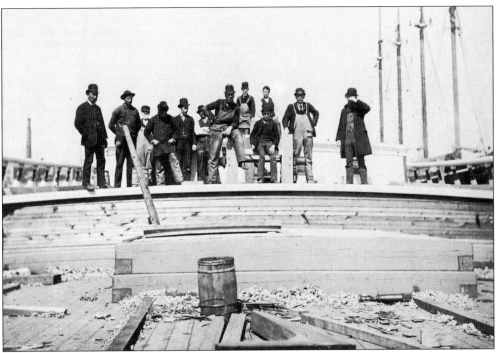

A group of men pose on the poop deck of the *Alma Cummings*. These remarkably well-dressed shipbuilders, complete with derbies, were part of a breed of builders that were fast disappearing by the turn of the century. (Courtesy of the BPL)

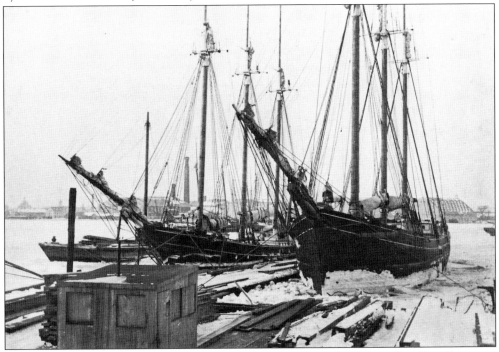

Two three-masters were docked at McQuesten & Company's lumber yard in East Boston in 1890. The *Messenger* is on the left. (Courtesy of the BPL)

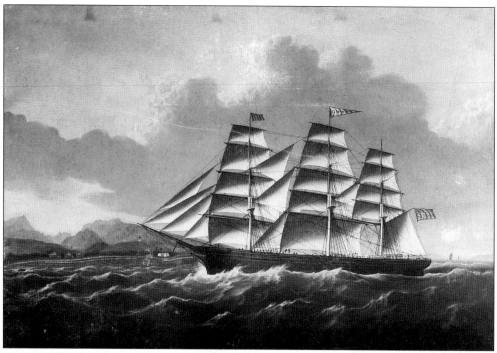

The ship *Ellen Monroe* was built in 1864 by J. Taylor of East Boston. (Courtesy of the BPL)

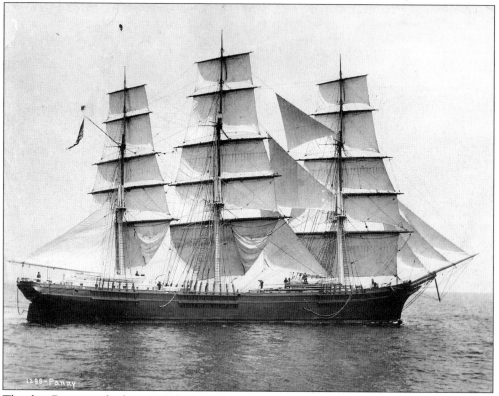

The ship *Panay* was built in 1877 by J. Taylor of East Boston. (Courtesy of the BPL)

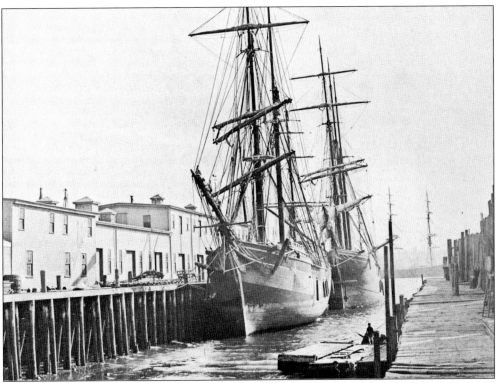

Carlton's Wharf was at 57 Sumner Street in East Boston and was photographed in the late nineteenth century as young boys stare at a brig and a barkentine. (Courtesy of the BPL)

At William McKie's shipyard, joiners are working on the *Alma Cummings*. Across the harbor can be seen the shiphouses of the Boston Navy Yard in Charlestown. (Courtesy of the BPL)

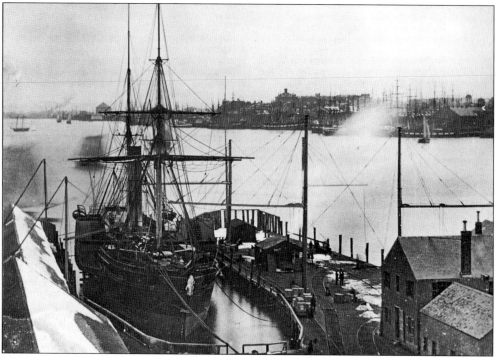

The *Niagra* was photographed in the Atlantic Dock in East Boston. Built in 1848 for the Cunard Line, the ship provided Atlantic crossings from Boston to Liverpool until being sold in 1862. (Courtesy of the BPL)

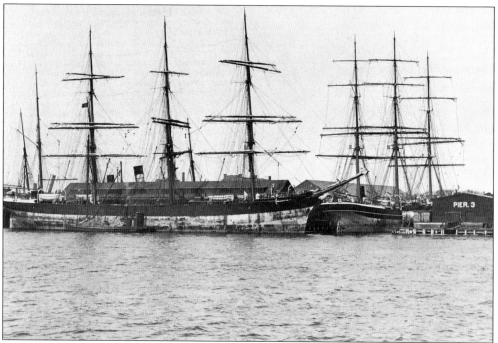

The bark *Arracan* and the ship *Scottish Lochs* lie at Pier Two of the Boston and Albany grand junction. (Courtesy of the BPL)

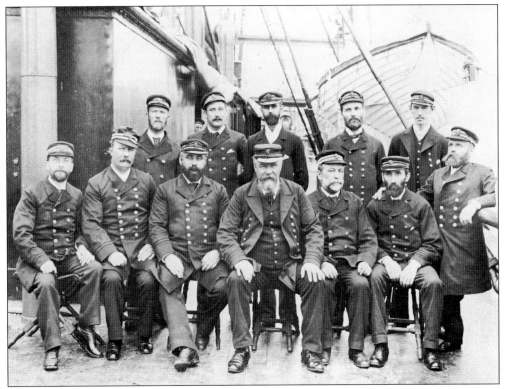

Officers of the ship *Pavonia* were photographed on board in 1892. From left to right are as follows: (seated) First Officer Cresser, Chieh Officer Inman, Chief Engineer Foulds, and Second Engineer Coutts; (standing) Fourth Officer Highes, Engineer Allsop, Engineer Grindley, Third Engineer Campbell, Engineer Paynton, and Third Officer Kidley. (Courtesy of the BPL)

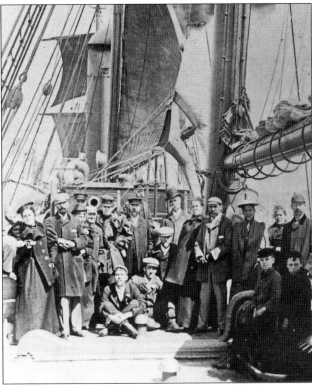

A group of "First Cabin" passengers sailing for Liverpool, England, pose on the deck of the ship *Pavonia*. Well and warmly dressed, the passengers seem prepared for the ocean winds, a rolling ship, and hopefully an enjoyable passage. (Courtesy of the BPL)

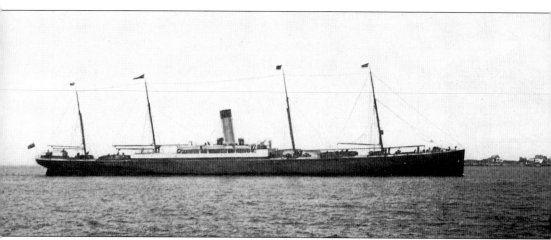

The steamship *Armenian*, shown here leaving the East Boston piers for Europe in 1895, was part of the Leyland Line.

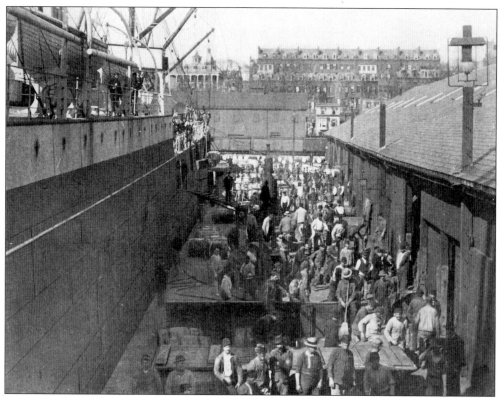

The steamship *Cestrian* of the Leyland Line is discharging freight at the Boston and Albany docks off Marginal Street in 1895.

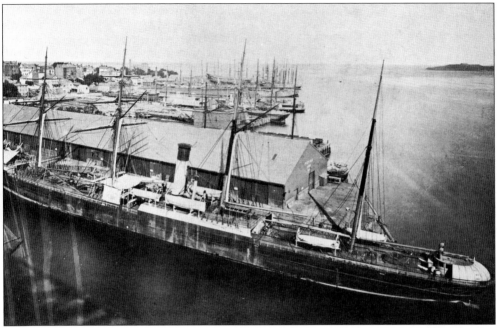

The ship *Istrian* of the Leyland Line was photographed in 1876 at dock in East Boston. (Courtesy of the BPL)

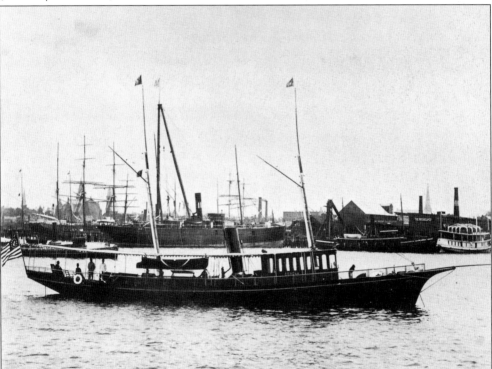

The yacht *Corona* lies off the Atlantic Works on Border Street in East Boston. The warehouse of Mitchell & Company is on the right with the spire of the Most Holy Redeemer Church rising high above it. (Courtesy of the BPL)

Colonel George B. Billings was the immigration commissioner for the Port of Boston at the turn of the century.

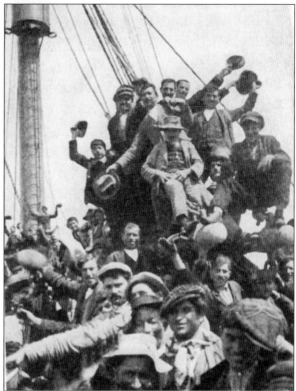

A group of European immigrants catch their first glimpse of the New World as their ship enters Boston Harbor. Their assimilation began at once upon arriving at the Immigrant Home on Marginal Street.

Boston Harbor, between downtown Boston and East Boston, was but a short distance. The warehouses of Cunard & Company are on the right.

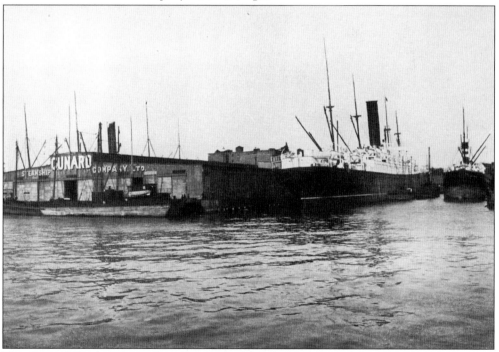

The Cunard Docks were enlarged considerably after Sir Samuel Cunard began using East Boston for his line in 1839. Clipper ships had given way to ocean liners by the turn of the century.

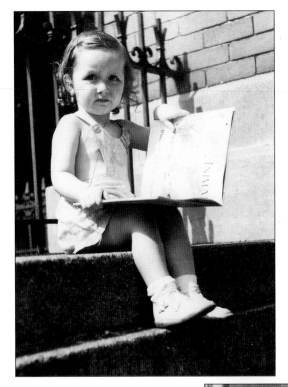

This young patron of the East Boston Branch of the Boston Public Library proves that you're never too young to enjoy a good book. Sitting on the steps of the Meridien Street entrance, she looks up from her picture book, *Animal Kingdom*. (Courtesy of the BPL)

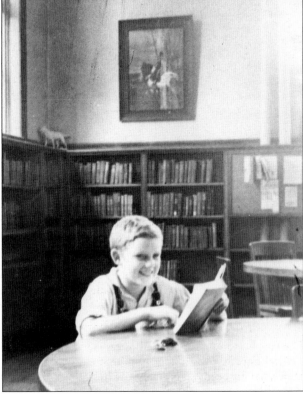

James Grasso reads in the Children's Room in 1955. His smile is evidence that he is enjoying Mark Twain's *Huckleberry Finn*. (Courtesy of the BPL)

Eleven

The Library

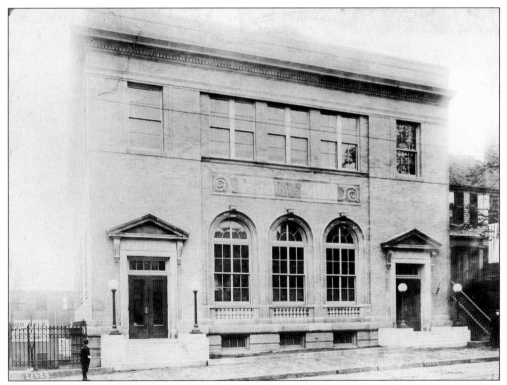

The East Boston Branch of the Boston Public Library was built on Marginal Street, just north of Central Square. This library has the honor of being the oldest branch library in the United States, having been established in 1870 by the Trustees of the Boston Public Library. (Courtesy of the BPL)

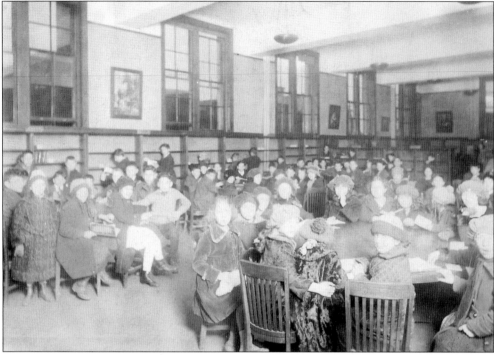

The Children's Room at the library was a popular place on afternoons following school. Children sit around large round tables in 1920 reading and doing their homework. Notice the empty bookshelves! (Courtesy of the BPL)

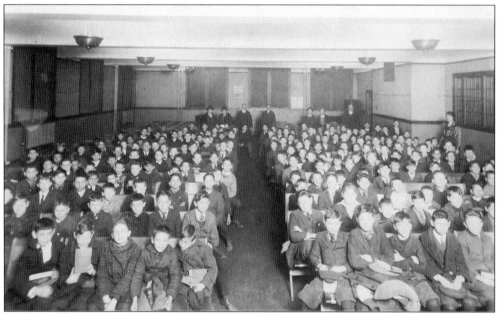

Boys await a story in the auditorium in the basement of the library in 1928. The Story Hour was sponsored by the Americanization Committee, which was established in the early 1920s to familiarize the children of immigrants with the customs of the United States. (Courtesy of the BPL)

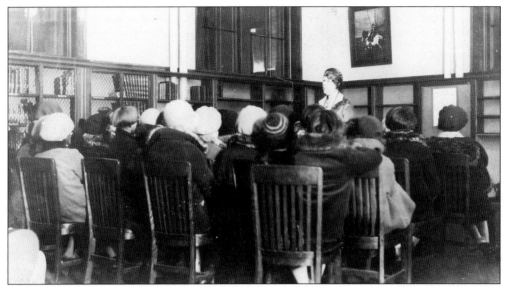

The girl's Story Hour was offered in the Adult Room by the branch librarian. One of the greatest story tellers was Mary Cronin, the librarian, who "was a large florid woman who told . . . all the children's classics, the great fairy tales, all the mythology of Greece and Rome." (Courtesy of the BPL)

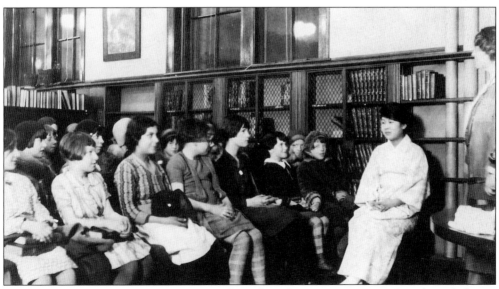

One afternoon in 1930, a Japanese woman dressed in a kimono came to speak to the girls during their Story Hour. (Courtesy of the BPL)

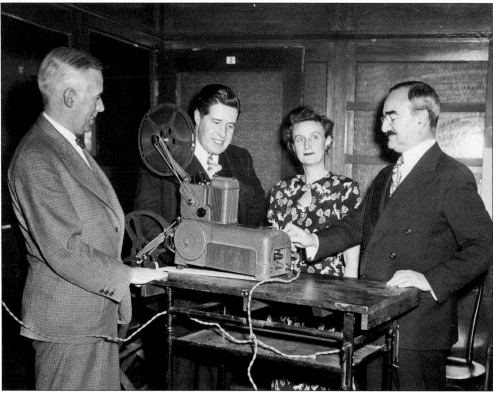

A new film projector was acquired by the East Boston Branch of the Boston Public Library in 1947. From left to right are Milton Lord, director of the Boston Public Library, Albert West, Dorothy Nourse, and Judge Abraham Pinanski. (Courtesy of the BPL)

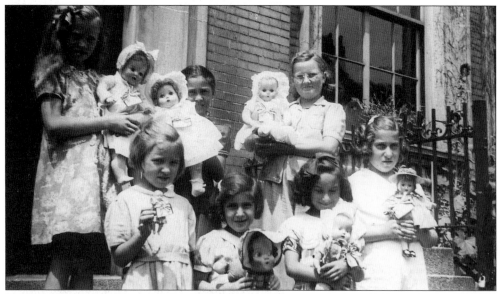

Holding their prize-winning dolls, these girls were photographed in 1942 on the steps of the library following the Doll Story Hour. (Courtesy of the BPL)

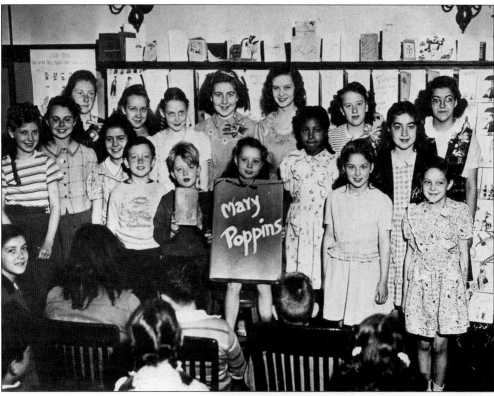

On the "tenth and a half birthday of Mary Poppins" (May 1946), children acted out the play and pose proudly in front of their audience. (Courtesy of the BPL)

Clara Cushman portrayed Mary Poppins in the play on May 26, 1946, at the East Boston Library. (Courtesy of the BPL)

The Jeffries Point Branch of the Boston Public Library was on the first floor of this wood building on Webster Street opposite Belmont Park. (Courtesy of the BPL)

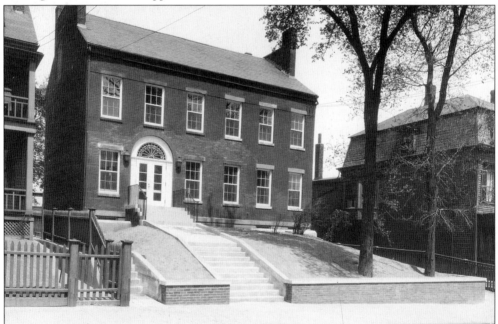

The Boston Public Library purchased a brick duplex house on Webster Street and converted it into the new branch library in Jeffries Point. Today, this is a private residence. (Courtesy of the BPL)

Twelve
Industries

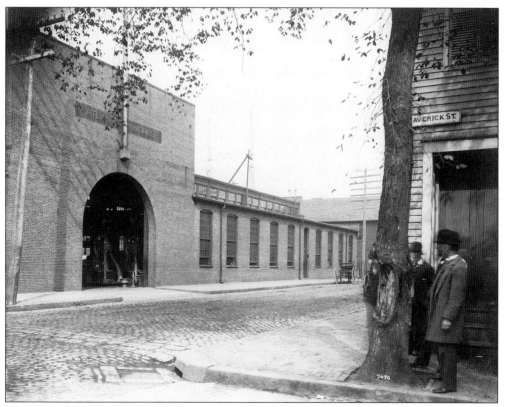

Three men look toward the Atlantic Works on Border Street opposite Maverick Street in 1910. The Atlantic Works was the largest manufacturing concern in East Boston for over a century, specializing in marine work. Steel yachts, tugs, and various steam sailing crafts were built and launched here. (Courtesy of SPNEA)

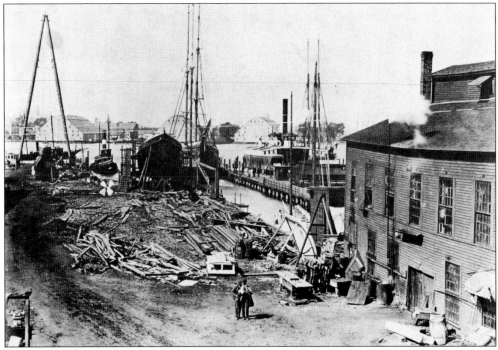

The rear of the Atlantic Works fronted onto Boston Harbor. In the distance can be seen the Boston Navy Yard in Charlestown. (Courtesy of the BPL)

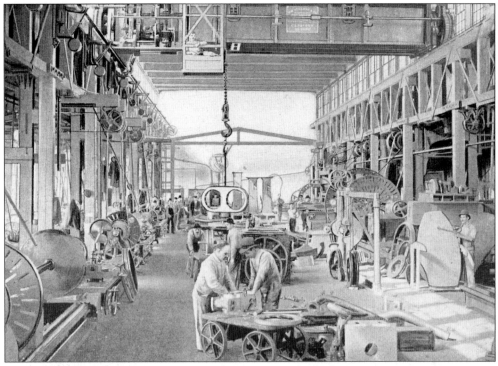

An interior photograph of the machine shop at the Atlantic Works shows men working on machinery that would be used on ships.

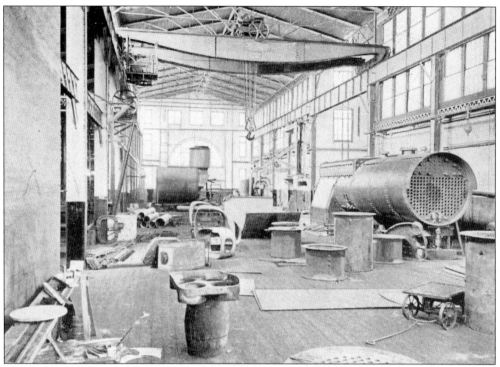

The boiler shop at the Atlantic Works produced massive boilers that were used on ocean liners.

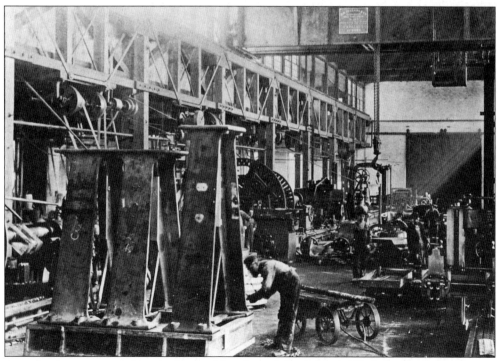

A worker inspects a machine in the machine shop of the Atlantic Works on Border Street.

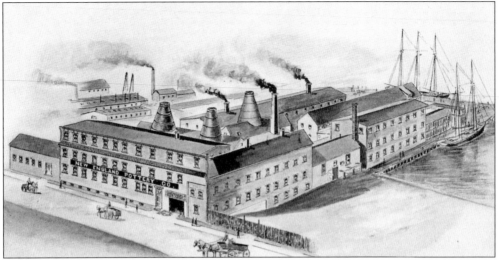

The New England Pottery Company was located at 146 Condor Street and was established in 1854 by Thomas Gray. Here was made table and toilet ware, tea and chocolate pots, cupsidores, and vases, as well as porous cells for electrical purposes.

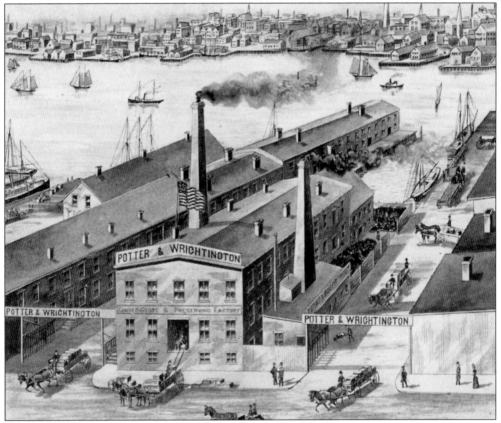

Potter and Wrightington had their canned goods and preserving factory in East Boston. Henry Potter and Charles Wrightington provided not only canned goods but packaged fish and cereal as well.

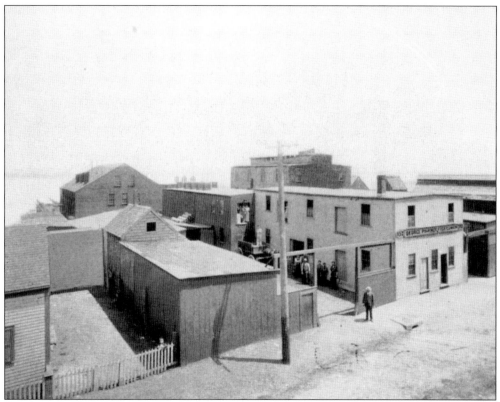

George Parker had his wharves and his fish-curing and packing house at 388 to 394 Maverick Street. An importer and smoker of domestic and foreign bloaters, and the manufacturer of "Parker's Flaked Codfish," he shipped his product throughout the country.

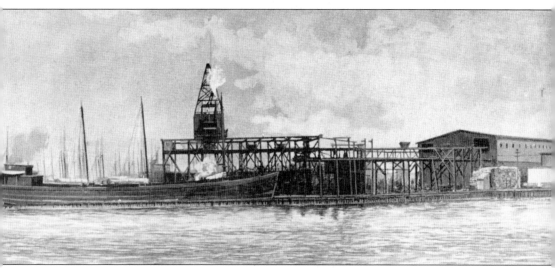

The coal dock, elevator, and wharf of Joseph Robbins & Company was located at 178 Border Street. Established in 1844, the coal was discharged from barges with a steam shovel and housed by cars running automatically on an elevated cable railway.

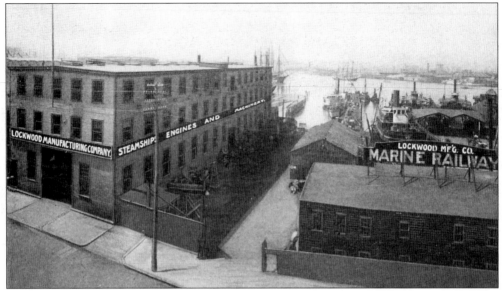

The machine shop of the Lockwood Manufacturing Company was adjacent to the landing of the North Ferry on Sumner Street. Here workers would build steamships, steam yachts, tow boats, marine engines, and cordage and rope machinery.

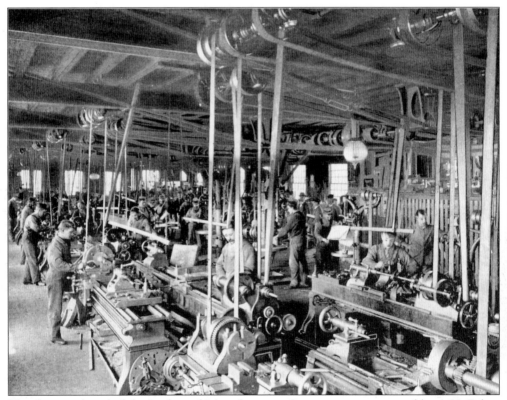

The shops and yard of the Lockwood Manufacturing Company were managed by A.H. Folger and were on the waterfront, just south of Maverick Square.

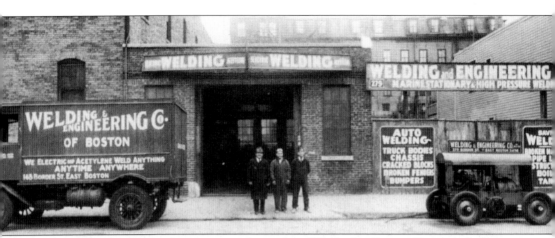

The Welding & Engineering Company was located at 279 Border Street. Photographed in 1936, three men stand outside the entrance with signs offering machine, stationary, and high-pressure welding. (Courtesy of the East Boston Savings Bank)

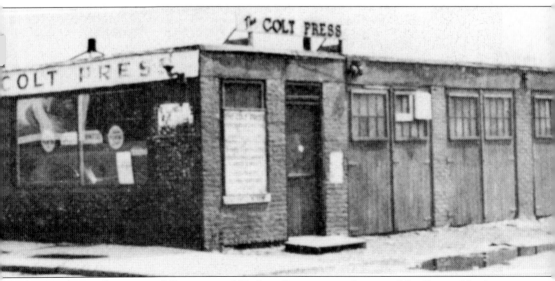

Colt Press was at the corner of Saratoga and Trident Streets, now the site of the Orient Heights Branch of the East Boston Savings Bank. (Courtesy of the East Boston Savings Bank)

Acknowledgments

I would like to thank the following for their support and continued encouragement: Daniel J. Ahlin, Vito Aluia, James Banfield, Anthony Bognanno, Paul and Helen Graham Buchanan, my ever-patient editor Jamie Carter, Debra Cave, Lorna Condon, and Ann Clifford of the Society for the Preservation of New England Antiquities, Edith De Angelis, Julie Deak, Dexter, the East Boston Savings Bank, Edward W. Gordon, the Hyde Park Historical Society, Tony Jacaloni of Tony's Realty, James Z. Kyprianos, Mary Linn, the Lynn Historical Society, Roberta Marchi, Sarah Markell, Jonathan T. Melick, Stephen and Susan Paine, John Penta, Maureen Piraino of the Public Facilities Department, City of Boston, Dennis Ryan, Anthony and Mary Mitchell Sammarco, Gilda Sammarco, Rosemary Sammarco, Robert Bayard Severy, Larry Smith, Sonny Tarbi, Kenneth Turino, William Varrell, Virginia White, and Branch Librarian Timothea McCarthy and the staff of the East Boston Branch of the Boston Public Library.